Montreal 24

Montreal 24

Twenty-four Hours in the Life of a City

Bill Brownstein

PHOTOGRAPHS BY
Daniel Francis Haber

Véhicule Press

Published with the generous assistance of The Canada Council for
the Arts, the Book Publishing Industry Development Program of the
Department of Canadian Heritage and the Société de développement des
entreprises culturelles du Québec (SODEC).

Cover design: J.W. Stewart
Cover photographs (front and back): Daniel Francis Haber
Special thanks to David LeBlanc
Set in Adobe Minion and Bodoni MT Black by Simon Garamond
Printed by Marquis Book Printing Inc.

LIBRARY AND ARCHIVES CANADA CATALOGUING IN PUBLICATION

Brownstein, Bill
Montreal 24 : twenty-four hours in the life of a city / Bill Brownstein ;
photographer, Daniel Francis Haber.

ISBN 978-1-55065-244-4

1. Montréal (Québec)—Social life and customs–21st century. 2. Montréal
(Québec)—Biography. 3. Montréal (Québec)–Pictorial works. 4. Bars
(Drinking establishments)–Québec (Province)–Montréal.
1. Restaurants–Québec (Province)–Montréal.
I. Haber, Daniel (Daniel Francis) II. Title: Montreal twenty-four
FC2947.3.B76 2008 971.4'2805 C2008-904267-0

Published by Véhicule Press, Montréal, Québec, Canada
www.vehiculepress.com

Distribution in Canada by LitDistCo
orders@litdistco.ca

Distribution in U.S. by Independent Publishers Group
www.ipgbook.com

Printed in Canada on 100% post-consumer recycled paper.

Montreal 24

For
Paul de Chomedey de Maisonneuve, who, though he might be
surprised to see it now, founded in 1642 what was to become Montreal,
thus paving the way for generations of other party animals to keep
rediscovering the city.

Acknowledgements

Martha Chodat; Dan Haber; Joey Little (for bringing Dan into focus); to those citizens of the city who, after being virtually ambushed, graciously accepted Dan and me into their lives; Simon Dardick and Nancy Marrelli; and, of course, Debi or Deb.

Introduction

It started with a bagel. An alleged bagel, that is. It was spotted at a Hamilton supermarket. It was red and it was suffocating in cinnamon and icing sugar. It was being billed as a "Montreal-style bagel." This blasphemy not only led to a showdown in the form of a blind taste-test—pitting the best Montreal bagels against some upstarts from Steeltown—but it also led to a heated debate as to what constitutes "Montreal-style." After my initial column on the subject appeared in the *Montreal Gazette*, readers, many of them ex-pats, reported in from far and wide offering similar horror stories.

Jim McDonagh, clearly a wise man from St. Catharines, Ontario, echoed the sentiments of almost all who responded to this story:

> Bagels in Hamilton are no match for Montreal bagels. But I have found many types of food here in southern Ontario that are displayed with a sign stating "Montreal-style," especially foods like smoked meat, hot dogs, steaks, poutine, BBQ chicken, spruce beer, souvlaki, cheese cake, bagels and the list goes on. No city in Canada sells such distinctive foods like Montreal does. The one sign I have not seen in this part of Ontario is a sign for Toronto Maple Leaf tickets stating Montreal-Style Hockey!

One indignant ex-Montrealer living in Ontario shared this life-shattering experience:

> I am reminded of the "Montreal-style" smoked-meat sandwich I ordered in Calgary a number of years ago: two meagre slices of pastrami on a Kaiser bun with honey mustard, Swiss cheese

and alfalfa sprouts. I have since learned to avoid "Montreal-style" anything, unless I get it in Montreal.

A couple of barrister buddies were so incensed over the Montreal-style cinnamon-and-icing sugar abomination that they contemplated launching a class-action on the part of the city over false advertising.

True, no one has a copyright for bagels or smoked meat or, for that matter, poutine or BBQ chicken. The bagel-meisters of Montreal will say that a true Montreal bagel is one made by hand, then boiled in honey water and baked in a wood-burning oven. Yet many have tried that seemingly simple formula around the world and have failed miserably. Some attribute the difference to the Montreal water or the honey or the wood-burning ovens.

Or just maybe someone has sprinkled some magic dust over our bagel and smoked meat and poutine. All of which brings up the subject of 'Montreal style.' Truly, it's easier to label what isn't Montreal style than what is.

For example, any alleged bagel coated in cinnamon and icing sugar isn¹t Montreal-style. Nor will pastrami, with alfalfa sprouts and Swiss cheese, on Kaiser bun with honey mustard ever pass for a Montreal-style smoked-meat sandwich.

Montreal has a style that can't really be explained in a few sentences. But it's something that can be felt by Montrealers and envied by others. For a city that many gave up for dead not that long ago, Montreal offers a life like few other metropolises on the planet. On the surface, that makes no sense—not even to diehard Montrealers.

The politics in Montreal border on Byzantine. The politicians are, by and large, bizarro. The winters are endless. The summers are a blur. The potholes are epidemic. The construction is never-ending. The infrastructure is crumbling. The head offices are long gone. An annual Stanley Cup parade is no longer de rigueur (the only consolation here for Montrealers is that Torontonians have had to wait even longer). The Expos are history. The Olympics are a distant memory (and maybe from a tax-payer¹s point of view, that's just as well). Oh, and did we mention, that Montreal is no longer the financial capital of the country.

And yet, and yet, the city has a hold on me and countless others.

Some would call us masochists. Perhaps. Essentially, though, we just want to have a good time, because the merry-go-round ride we call life is ultimately a ride too brief.

For better or worse, Montreal is and will always be my city. This is a book about 24 hours in the life of a city that never sleeps. Action takes place between midnight Thursday and midnight Friday in the fall, after most of the tourists have split and Montrealers have once again regained control of their city. The book showcases the people and places that make Montreal unique. It illustrates how "Montreal style" trumps the negative stuff almost every time.

And by the way, the burghers of Hamilton got their butts kicked in the blind bagel taste-test. Duh.

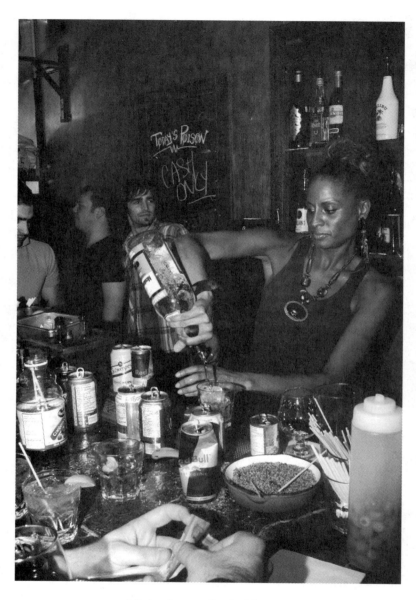

Mixing it up at Garde-Manger.

Midnight

IT'S PITCH BLACK OUTSIDE. It's a brand new day. Or night. Depending on your perspective. Seraphim Cotsadam only knows the night. He works the graveyard shift, driving a hack through the streets of Montreal. He's not sure he always likes what he sees. His first name has biblical roots. He has Greek roots. But he relates mostly to Bobby De Niro's roots, as depicted in the seminal flick *Taxi Driver*. This gives his passenger serious pause. With his long brown locks and chiseled good looks, Seraphim, in spite of the baggy eyes, could pass for an actor, though not De Niro. But he would rather be a writer.

"The people I have driven, the conversations I have heard, the stories they tell—no one would believe," he says with a huge sigh, as we snake through the cobblestoned streets of Old Montreal. "There are so many crazy people out there. But most people never see them. They're scared of the sun. They only come out at night."

Vampires?

Seraphim simply smiles. He drops off his passenger on the once-moribund—late-nights, anyway—St. François-Xavier Street. Silence may prevail elsewhere in Old Montreal. But outside Garde-Manger, deemed hippest place in Montreal by no less than NBC's *Morning Show*, a mob has gathered. They don't look like vampires, and they don't look that crazy either. They are party people. They are smoking—because they can still do it outside—and they are scoping. Traps—of the passive aggressive socio-sexual variety—are being set.

Garde-Manger is so cool, it doesn't even have or need a sign outside. Those who have to know, know. Others need not apply. Inside, the place is wall-to-wall astonishingly beautiful women, mostly under thirty, in astonishingly smashing threads. They dance. They drink. They eat. All under the watchful gaze of guys, mostly well-appointed and under thirty, who seem to want little more than to adore them and ply them with shots and, if necessary, food.

The decor is minimalist industrial chic. Exposed brick walls. Functional chairs and tables. Simple bar. Kitchen staff work in an adjacent cage. There is little room for staff or clients to maneuver. This entails a lot of unavoidable touching.

Tim Rozon is one of the three owners, all early thirtysomethings. He is as surprised as anyone about the place's quick rise to the top of Montreal's hip heap. "We never advertised. We never even thought about putting up a sign. We're just three guys who aren't afraid of a little hard work."

Seems simple enough. Except that Rozon and his partners are stars on the city circuit, having worked at what were, at the time, the hippest establishments on the Main. They know pretty much everyone who matters and many who don't. Doesn't hurt that Rozon is also one of the city's designated hotties, according to the two babes draped over him. His movie-star good looks, with a dash of innocence, are put to excellent use on the hit Canadian TV series *Instant Star*—a title that kind of sums up Rozon.

But give Rozon his due. He doesn't skate on the image. He does windows, and then some, like his two partners. Which accounts for the overnight success of Garde-Manger. How else to explain one of the previously deadest streets in Old Montreal coming to life?

"We figured Old Montreal was ready for an explosion like us," Rozon nonchalantly says, between hauls on a cigarette. "But we never figured on this. It's busier than we ever imagined. It's busier than we actually want. We were just looking for a place to hang with friends. But somehow the anti-scene became the scene."

The key?

"Simple," shoots back the T-shirt-clad, cap-sporting Rozon. "There are two kinds of bees: queen bees and worker bees. We're worker bees. We have no time for queen bees."

Rozon is working the door outside Garde-Manger, trying to keep smokers outside and drinkers inside. He doesn't normally work the door, 'cept that his regular doorman didn't show. A few minutes earlier, he was doing the deejay thing in the music pit behind the bar, because his regular deejay turned up late. Later, he'll probably sling a few cocktails at the bar, but mostly because he likes to.

One of the customers heading into the street informs Rozon that it's like a steam bath inside. Rozon flashes his sweetest aw-shucks grin. "My bad," he says. "I put the heater on by mistake instead of the air conditioner. Sorry."

Hey, heat happens.

On further reflection, Rozon feels the food is a big draw. "But that's not it entirely. It's just this loud, crazy place, that people obviously need in which to unwind. I've lived in Toronto, too. There, they live to work. Here, we work to live."

Anything else? "Yeah, Montreal has the hottest women in the world." So it has been said. And it appears that many of them congregate at Garde-Manger. As do cross-border beauties like Halle Berry and Joss Stone, when they're in town.

"Robert Englund was hanging out here while making a movie," Rozon notes. "But he scared the shit out of my bartender, who knew him only as Freddy Krueger."

And here's the thing about Garde-Manger. Even if Freddy Krueger were to show up, Rozon states, he wouldn't deny him entry. "If there's room, we let just about anyone in. We're not one of those poseur, pretentious places with bogus long lineups. We're not snobs. Hopefully, we'll never be snobs."

Cook Sean Glasgow, who has just exited, has flipped his last steak and sautéed his last salmon for the night. He's bushed. And he's soaking wet. "Sorry, Sean, turned on the heat instead of the air conditioner," Rozon tells him. Tough enough to cook in the steaming hot pit, but to do so without air ... whoa!

"No worries," says Glasgow, who has toiled in the kitchens of L'Express and 737. "The hours may be long and hard here, but I'm learning new stuff. I'm experimenting. It's like a breath of fresh air." Even if the air ain't fresh.

For the record, Glasgow lost fifteen pounds over the last few weeks, just working in the kitchen—with the air conditioning on. He suspects he might have lost about ten pounds on this evening alone. Hope not, because he's already reed thin and at this rate, he'll end up weighing less than a Garde-Manger porterhouse.

A young hipster tries to extinguish his cigarette in a plant next to

the door before entering. Rozon stops him: "Why would you wanna kill this plant? What did the plant ever do to you?" The young hipster looks stunned and butts his cigarette out on the sidewalk instead.

"Smoking is a problem, now that it is illegal to do it inside," Rozon says. "Sometimes I feel like I'm stuck outside in the world's biggest ashtray. But better outside than in."

Rozon would like to deflect all kudos for the restaurant's success to his partners Kyle Marshall Nares and Chuck Hughes, the chef: "Kyle is so good, he has two last names. But he is the backbone, the glue of this place. He's here all the time—except tonight. And Chuck is the brains behind the kitchen. Me, I work when I'm here. Pour a few drinks. Spin a few discs. Handle the door if necessary. But they allow me to pursue my acting career. I can't take any credit." Well, maybe for saving a plant.

Inside, Dimitri Antonopoulos is all smiles. Not only because he is cozying up to the enchanting Kathie Deneault at the bar, but also because it has been his and his family's dream to help transform Old Montreal into the bustling destination spot it has become. Antonopoulos, all of twenty-nine, is one of the masterminds behind his family's fast-growing operation that includes the swank Place d'Armes Hotel and the funky Hotel Nelligan, which is not only named for one of the great Québécois poets, Emile Nelligan, but whose rooms all pay homage to him. The Nelligan is also home to Méchant Boeuf Bar & Brasserie, while the Place d'Armes has the coolest rooftop bar around.

Antonopoulos invariably drops by Garde-Manger on his way home from work. It's not the most direct way, but what the hey. "It does the heart good to see Old Montreal so alive," he enthuses. "Montrealers just want to have fun. They know good atmosphere when they find it. And this is the ultimate atmosphere. It's not something you can make with instructions. It's magic. Some places have it. Most don't."

Deneault is head of human relations for the Loblaws grocery chain in Quebec. She lives in Old Montreal, which is fortunate because she can glide home. "I live in a *Sex-and-the-City* loft," she purrs. "This city is all about lifestyle. It's affordable and there's no comparison anywhere. I love to travel, but I love to come home even more. The people are beautiful, inside and out."

A waiter is delivering a bottle of high-end champagne, replete with

sparklers, to a woman at an adjacent table. What's the occasion?

"Life" is the reply from the young recipient, who could pass as a model but who is actually a receptionist at a law firm.

"I love this city," Antonopoulos says. "People need no excuse to have fun. Life works here. I go to London, Paris and New York, where people feel they have to go to super-exclusive places to have a good time and they end up not having a good time. Here there are no barriers. There isn't that kind of pretension. Maybe we're no longer the financial capital of Canada, but we're happy and know how to live. In the end, that matters most."

[Garde-Manger, 408 St. François-Xavier]

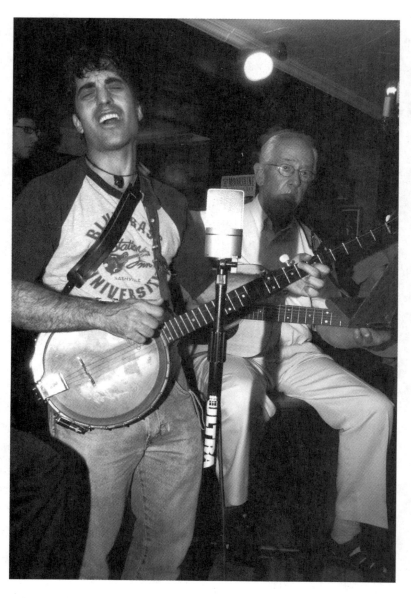

Bluegrass on Bishop Street! Who knew?

1 a.m.

THE WAILINGS OF HANK WILLIAMS call out. Or maybe a reasonable facsimile. Okay, it's not that reasonable. Hell, the human who's wailing isn't even a guy. And she's not even wailing a Hank number. But, damn it, it is bluegrass. And it's a most unlikely genre of music to be emanating from Montreal's downtown core. House, funk, rock, jazz, hip-hop, classical, blues, yeah, sure—but a bluegrass mecca on Bishop Street? You bet your banjo! Nope, these words are not the ravings of some miserable soul who has overdosed on a bad vat of moonshine and/or one too many viewings of *Deliverance*.

Hard as it may be for urban hipsters to fathom, bluegrass has been thriving at Grumpy's Bar the last few years, on Thursday nights spilling into Friday mornings. The event is called Moonshine on Thursdays, despite the fact that it's now a little past one in the morning and the wailings go on unabated. Tonight's a special occasion: Moonshine on Thursdays' fourth anniversary. There may not be any chuckwagon on Grumpy's terrace, but if grilled hot dogs count as grub, there's plenty of it. And there's everyone's favourite urban cowboy, Lonesome Larry Whitaker, and his Lonesome Pine Band, who have just finished their set. And now it's the circle jam, with two dozen pickers and thumpers and strummers and crooners. There are banjos and mandolins and guitars, but no drums. And no amps. 'Cause that's not the way it is with bluegrass traditionalists. Hank just wouldn't approve. There is one mic, though, available to the wailers. Hank would have approved of that.

About the only thing missing, in fact, is moonshine strong enough to make you go blind.

The beer, on the other hand, is flowing. Just have to mind those bottles that could go whizzing by your ears at any moment. It depends on the mood of beer-tossin' Gern f. behind the bar. Moonshine on

Thursdays is the brainchild of Gern f., a part-time Grumpy's bartender and full-time member of the United Steelworkers of Montreal—which is not a gaggle of steelworkers but, in truth, one dynamite down-home bluegrass ensemble.

Though he could pass as a steelworker and has spent much of his life doing chores requiring the same stamina and strength, don't let his imposing presence unnerve you—unless you plan to duck out on your bar bill. Gern f. is decent folk. He has also made it his mission to make old-time country music a mainstay in Montreal. He joins the ranks of such Country & Western crusaders as Bob Fuller, whose Monday hillbilly nights, now at the west end Wheel Club, have survived all manner of peril over the decades, as well as Matt Large of the group Notre Dame de Grass and Mark Peetsma of Catfish and Kleztory, both of whom do Sunday bluegrass nights at Barfly on St. Laurent Blvd.

But first things first: what does the 'f' stand for? "ffffff....," shoots back the gravelly voiced Gern.

Could be for "funny," but judging by his intonation, we're guessing not. Still, Gern f. is able to sling one-liners with the same facility as he slings brews. In trying to define the "old-time" music he most favours, he confesses that no one knows what that means, "except to say that none of its fanciers are twenty-five or single, and that it's basically everything that came before Hank Jr."

That would be Hank Williams Jr., son of the legendary Hank at whose altar Gern f. and Bob Fuller and other bluegrass diehards still worship. Not that Gern f. can't kibitz about Hank Sr. "Hank wrote 140 songs that all sounded the same, in two keys and four chords, and fifty became classics. He was truly a classic."

Gern f. drifted to Montreal from the hinterlands of rural Ontario fifteen years back. "The timing was great. I came in the midst of a drought. No one had money or jobs. Everyone else I knew was moving west. But I'm like a fish swimming upstream."

Regardless, he was quick to settle in town and to hook up with the United Steelworkers of Montreal, with whom he plays guitar and sings. "I'm more of a thumper and I'm not known for finesse guitar-picking." No matter. He is known for his battle to keep bluegrass alive here. As well as to provide a showcase for this city's coterie of overlooked women

singers and musicians. Go figure: Gern f, one of the toughest-looking hombres in town, is also one of the driving forces behind Chick Pickin' Mondays at Grumpy's. "The music industry is almost impossible to penetrate at the best of times," grunts Gern f., this city's gift to the women's movement. "Needless to say, it's especially tough on women."

To further demonstrate his sensitivity, Gern f. is also the genius behind Grumpy's weekly Bitch About Your Boss contest on Monday evenings. Participants recount their horror stories on the job. Then the audience decides on the winner, who receives an Irish Car Bomb—the cocktail.

"There have been some sad stories," Gern f. acknowledges. "But the saddest of all had to be the guy who had gotten fired a couple of hours earlier. Why? Because his boss had been sleeping with this guy's wife, and the boss didn't want him around any longer. Now that bites. But what was worse was that the poor guy didn't even win the contest that night. So I bought him a few shots to help deal with his hurt."

And Gern f. concedes he was inspired to pen a heartfelt tune about the fellow's hurt—which will likely surface at a coming Moonshine on Thursdays. If he can get a few minutes alone on the makeshift stage, that is. What sets the bluegrass at Moonshine on Thursdays apart from that offered at other local establishments is the circle jam, wherein everyone's invited to join in the free-for-all. "And if you don't know the chord, just watch the guy playing next to you—unless it's a banjo player, 'cause no one ever knows what chords they're playing," explains Gern f.

As eclectic as are the performers in the circle jam, so, too, are the onlookers at the bar. Take boulevardier Jim "Bow-tie Guy" Le Vogueur. Or his buddy Denis Ouellet. Bow-tie Guy is in the shipping business— big ships, that is. He is also a pilot. And a guitarist. And a singer, who used to belt Bach and Berlioz with the St. Lawrence Choir—which provided vocal accompaniment to the Montreal Symphony Orchestra. But Bow-tie Guy has a passion for bluegrass and banjo and is a regular at Barfly's weekly homage. His upbringing in Cornwall, Ontario might explain his devotion.

Ouellet is also a pilot—which accounts for his friendship with Bow-tie Guy. He comes from the relative wilds of Rimouski. He used to be an air-traffic controller, but he gave up chasing blips on radar

screens to design and build loudspeakers. His dad was a fiddler, and Ouellet swears that except for the language of the songs, bluegrass is pretty darned close to the traditional Québécois reels he was reared on. "My earliest memories growing up were concerts around the kitchen table organized by my grandfather," Ouellet says. "They had everything from spoons to fiddles. And they danced until the wee hours."

"Bluegrass is unprocessed and pure," indicates Bow-tie Guy. "There is nothing like the sound of a five-string banjo come alive."

There is nothing like the sound of a tone-deaf woman wailing "Four Strong Winds," either. But such is the laid-back nature of these bluegrass fans that no one will dare interrupt or mock her, either. That's the beauty of it all. Amateurs and pros mesh for the love of the music.

A more seasoned performer changes the tempo a tad with an inspired rendering of "There's No Hiding Place Down Here." Those in the circle jam as well as spectators like Bow-tie Guy join in the harmonies. "I paid my way through school and made a nice living doing Dylan songs," he recalls. Might have to re-dub him Renaissance Dude.

After finishing his studies at Montreal's Dawson College, he was supposed to attend the University of Guelph in Ontario. But fate intervened. He says Dawson failed to forward his marks in time, so he took a job as a sailor on a ship doing an eighteen-month tour of Africa and Europe. This somehow led to his becoming a broker, buying, selling and trading commodities, and then to moving them all on ships. But Bow-tie Guy would rather talk about the time he played guitar and spoons at a Crab Festival along the St. Lawrence River. "It was pure happiness. Like bluegrass itself."

Bow-tie Guy insists one can find absolutely anything in this city. "It's all here. There's no place like it. And it just comes alive at night. Most other cities see an exodus from downtown in the night. But here, it could be four in the morning, in the middle of a blizzard, and it's a party." Which is great, unless, like Bow-tie Guy, you have to be in front of a computer in about five hours to load ships and stuff.

"Best part, though, is that the politics here no longer depress me," Bow-tie Guy says between sips of beer. "Don't want to say it too loud, but I think we're over our crisis. Yet there's enough tension—like high

taxes and bad roads—to keep life just interesting enough."

Nursing a brew on the stool next to Bow-tie Guy is Ram Krishnan, who grew up with the soft sitar melodies of his native India. His mom is a professional performer schooled in the delicate movements of traditional Indian dance. So, he, of course, started a country band. Krishnan is also the manager of Grumpy's. "My mother has no problem with me fronting a country band. She's less wild about the bar business. Otherwise, people are pretty accepting here. I've lived other places, but that's why Montreal is so cool. It's like everybody's from somewhere else, and yet we all belong here."

The only problems of racial intolerance he's had to deal with have come from U.S. tourists. "About thirteen years ago, this Southern guy started screaming: 'What's with the darkie behind the bar?'" Bad move. Krishnan's burlier friends were not amused and let the bigot know in no uncertain terms.

"There's lots of energy and happiness going on here," adds Krishnan, whose band, The Jimmyriggers, enjoys a certain underground cachet. "My only gripe is that it's so hard to make it as an independent musician."

Right now, Grumpy's feels and sounds a whole lot more like a part of Appalachia than Montreal. Dara Weiss has just finished singing and plucking her guitar with her buddy, Erin Daley. Both are thirty-two, and would probably look more at home at some hard-rock venue. "But there's something magical about old-time country," Weiss comments. "It brings me such serenity." Weiss teaches music by day. Daley teaches English at a French radio station. Weiss is from Montreal, Daley from faraway Nelson, B.C. Daley yearns to bolt Montreal for the bush.

"I'm just sick of city life," Daley says. "So big. So many cars. So much noise. You could probably fit half of Nelson into this bar alone." Pause. "But bluegrass does make it better."

Weiss likes the country, but wouldn't trade the city for the quiet rural life. "This is my home. I'm comfortable here. I love the multi-cultural aspect. And there's bluegrass. What more could a gal ask?"

Daley concedes she probably won't leave Montreal any time soon. "This city has a way of sucking you in." Some might call it seductive, and Daley doesn't disagree.

Then there's Richard John Rossetto. He's not from these parts. He appears to have descended from another dimension, although he claims to come from small-town Alberta. Despite an appearance that could scare small children—especially when he bares his chest, as he is doing now, and makes frightening faces, accentuating his buck teeth—he says he's a people person. By day he works as a waiter at a hotel. By night he wanders the city, before retreating to his home where he paints under the name of ricHard. "My paintings are words on top of words making images. I'm all about Montreal. There is no barrier for me. The greatest thing about living in Montreal is the fact it is still relatively cheap to live here, so you can have all the big city action and still survive without having a million dollars. Also because it is cheap to live here you have a large mix of classes that intermingle at different spots. It creates an interesting scene. What I really love about Montreal is that although we are a huge city, because we are on an island it creates almost a small-town mentality where if you hang out long enough you end up knowing lots of people in different scenes."

Gern f. observes the scene from behind the bar. He is beaming. "I never figured to end up in Montreal. Before moving here, I had done just about everything—'cept being a steelworker. I've done every shitty job there is, including mucking horse stalls and castrating pigs." Ouch.

One thing he didn't do was knock over a few banks, like a couple of bored high-school acquaintances, who did three in small-town Ontario before getting busted and incarcerated. But their crimes did provide Gern f. with the inspiration to pen the tune "Small Town Banks."

Still, Gern f. is fully aware this city is far from being the country music hotbed he wishes it were. "Bluegrass is more a musicians' genre than a populist genre here. But I dream of the day that live C&W can be programmed nightly at a Montreal club." In the interim, he'll make do performing with the United Steelworkers. "We're still more in the giving than in the taking stage," he cracks, sporting an ear-to-ear grin. "But at least we're beyond our stealing-the-coffee-creamers-off-the-table stage."

[Grumpy's, 1242 Bishop Street]

2:00 a.m.

FROM THE OUTSIDE, it looks like a small, nondescript walk-up. Except for a lineup of kids outside a rope barrier and a phalanx of burly security guards on the other side of said barrier, there is nothing to indicate that what beckons upstairs is the city's most successful and popular nightclub. It's called Tokyo, although this club—on the Main below Pine Avenue—has nothing remotely to do with, well, Tokyo.

Once given the seal of approval by two security guards, patrons considered worthy begin the long ascent up the stairs. What looked like a hole in the wall is a seemingly never-ending maze of tunnels and terraces and rooms that hold up to 1,200 euphoric, mostly college-age kids. It's wall-to-wall-to-wall free-spending, free-drinking, free-smoking (on the terrace) carousing. There is nothing terribly distinct or interesting about the decor. The music is just loud. So what gives? According to bartender Ariel Goldstein, on the top terrace, it has something to do with kismet. Or the alignment of the stars. Somehow it was decided Tokyo was the place to hang for the city's club kids. And they descended en masse—from the east, west and the 'burbs. All languages, all cultures, all revellers.

It's a little less than an hour from closing time. As jammed as it is on the floors and terraces, so it is inside the plethora of bar areas. Goldstein is wedged between a bottle of vodka stuck uncomfortably close to his crotch and a bevy of barmaids. He can deal with the latter. "Every Thursday night, or I guess Friday morning as the case is now, it's insane like this," Goldstein says. "At first I figured the draw was the hot, handsome bartender. Me." He's half-kidding.

Goldstein will get about three hours sleep before hitting his day job in the creative development section of a local advertising agency. The extra bartending money—about $500 in tips for the weekend—helps. But that's not the reason he works here "Can't miss the party. It's

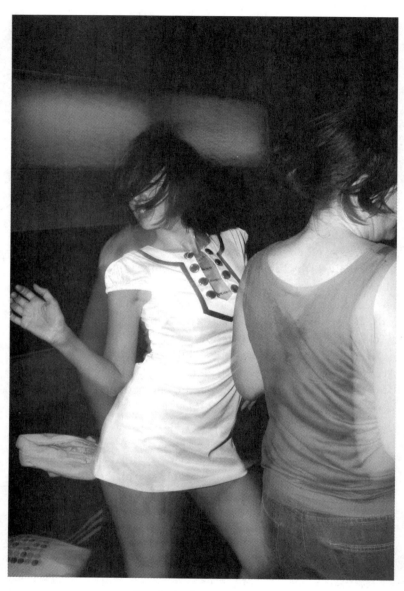

Caught in the Tokyo swirl.

the biggest in town. The women are out of this world. Everyone is here." Maybe everyone under thirty and over, hmmm, sixteen.

But where do these kids all get the scratch to buy not just a few cocktails, but quite often entire bottles of premium scotch and champagne that set them back as much as a grand? Even Goldstein is mystified. "A lot of them work and would sooner be broke and go without food for a week than show up with no cash for this party. Others have rich parents." And perhaps others have figured out ingenious ways to earn money that don't require hard work.

Goldstein says there are some nights when it's not easy to handle the "smart-ass college types." Next to us, some oversized jock type, not more than twenty-one, is trying to woo a woman with this come-on: "I own a corporation." What kind of corporation, the young woman inquires? "Oh, you know, just a corporation that makes stuff and investments. It does very well." Perhaps, but the jock doesn't, as the young woman up and bolts. She knows an urban fairy tale when she hears one.

Keeping a watchful eye over proceedings is Nelson Riquelme, the head of Tokyo's eleven-man security force. Headaches for Riquelme and his team will begin in about twenty minutes when they have to clear out the place. Some of the over-served college types resent having to leave, after having forked out major cash for their bottles of primo vodka. Some, particularly the over-served jock types, try to impress cronies and babes by confronting the security team. This is not wise. Riquelme, the smallest of the bouncer squadron, makes his living as an Ultimate Fighter. This means his hands and feet, as well as other body parts, are pretty much lethal weapons. He could, if provoked, pull out the tonsils of a bothersome client through a variety of orifices. Sometimes he is tempted.

"We have one of our less mature crowds here tonight," says the no-nonsense Riquelme. "I just caught a guy trying to take a pee in the corner of the terrace. I told him it wasn't a good idea. He wanted to know how much he would have to pay me to pee. I grabbed him by the neck and threw him out. Some of these kids think that because they have money they can do what they want. That bugs me a lot. I'm here to show they have to mind the rules and respect others."

Riquelme was born in Chile but moved to Montreal as a child and grew up around the corner from Tokyo. He's had four Ultimate Fights and has won three. He lost one by decision. "I may be the smallest bouncer here, but no one messes with me." He then proceeds to extol the virtues of Montreal. "This is the best city in the world. There is such a diversity of culture. There are such beautiful women here. And this has to be the best party town ever. In fact, without winter, Montreal would be as close as it gets to paradise on Earth."

While there may be a fair share of human beings at Tokyo who are not fully evolved, most are wise enough to split when advised by Riquelme. He won't back off. One night, he broke up a fight at the club. Later, one of the combatants returned with four of his friends to take on Riquelme. Not a wise move. Our Ultimate Fighter was forced to mow them all down. Another time, some punk chucked a shot glass at the head of an unsuspecting customer at the bar. This made Riquelme mad. "He could have killed the guy," he recalls. "I just grabbed him by the neck and tossed him out. It's sad when people behave like fools, but that's why it's necessary to have people like me to keep the peace."

If Riquelme is the smallest member of the team, Steve-Ryan François is the most humongous. He stands somewhere around 6 feet, 5 inches, and tips the scales at, he insists, 286 pounds. Yet there is nothing menacing about him. Of course, it's easy for the baby-faced François, twenty-three, to be mellow when he knows he could crush all comers. "But that's not me," he says. "I hate fighting. I hate confrontations." François has seen the more sordid side of the city, and it haunts him. "Sure, Montreal is so beautiful and fun on one level, but it also has many disturbing aspects."

François is of Haitian origins but has lived here most of his life. He isn't a religious man, yet he fears that we could lose all sense of values. "These are college kids here, but do they truly understand that education is the most powerful tool there is? I tell people that I would like to become a lawyer one day. They look at me and say I should become a football player because of my size, that I could make a fortune and retire young. But that's not what I want. I want to help my fellow man. They then look at me like I'm completely nuts. I just smile and walk on."

It's closing time at Tokyo. Some patrons are more sober than others. A couple of security guards are dispatched to a women's washroom where a couple of guys are up to something. Another guard is trying to convince a customer he can't take his half-finished bottle of vodka out with him. Gradually, the kids stream on to the street, where a half-dozen cops are gathered to encourage them not to loiter. There's a little tough talk, and some middle digits are thrust in the direction of the law and the Tokyo security detail. In the midst of this, François is helping a young lady who has just taken a tumble. He asks if he can get her a taxi. She declines. She asks him why he is being so kind. "If you respect others," he tells her, "they will respect you." She thanks him, then asks if he had to fight tonight. "Actually, I've never been in a fight here," he says. "I pride myself on that. And a person must have pride in themselves to survive." The young lady doesn't know what to make of that. She joins up with some friends planning to hit an after-hours joint up the street. "The party is only beginning," a girlfriend tells her. "We can't stop now."

"Have a good time, but be safe, please," François urges the young lady.

"I will," the young lady responds. "And thank you for giving a damn."

[Tokyo Bar, 3709 St. Laurent Boulevard]

3:00 a.m.

THIS IS ONE MAN who can live up to his name. Charilaos Darmas says that when translated from Greek his first name signifies someone who "brings joy to people." No doubt about that. All the same, he prefers that people call him Harry, which might not have the same significance but which doesn't necessitate having to write out Charilaos all the time for the curious.

Whatever you call him, he has packed a lot of living into his fifty-five years. You could call him a restaurateur, because he is, after all, the owner of one of the most fine, fun and lively Greek restos in town. Philinos is a landmark in the city's Greek Quarter on Park Avenue after only twelve years in operation. It's a family affair: Harry runs it with his wife and two sons—one serves as maitre d', while the other is a chef. Harry's brother and cousin also work there as chefs. Even the waiters and cooks unrelated by blood to Harry feel like they are kin.

There are those who would like to think they are people-persons, and there are those who don't think about it but are. Harry fits into the latter category. He radiates a genuine warmth. If you were to see him scurrying about Philinos picking up dishes and cleaning tables, you would probably assume he was the busboy, so unassuming is his manner. Like its boss, the restaurant is unassuming too: understated Mediterranean with warm, earthy colours and decor.

Even when he is conducting business at Philinos, Harry often looks like he's somewhere else, lost in thought. Frankly, he would sooner talk about humankind's evolution or the lack thereof than chit-chat about his mussels and lamb-chops—which just may be the best in town. Harry is a philosopher, which probably comes with the Greek roots. His concern for his fellow man is genuine. He's made fortunes. He's lost fortunes. It bothers him not a whit. It's man's inhumanity to man that keeps him awake nights.

Fortunately, Harry has an outlet for his blues.

It's 3:14 a.m. It's past closing time for customers, who tend to be mostly young, hip and a mixture of Greek, francophone and anglophone locals. They come to Philinos to dine and to party. They are never in a rush to leave. As the last merrymakers stride out the door, a couple of waiters are tidying up tables and sweeping floors. Harry fetches his bouzouki. Joining him are a couple of other musicians and singers. Soon his brother/chef Paris will emerge from the kitchen and take his place behind the piano in the corner of the restaurant.

In the wee hours of almost every Friday morning, it's bouzouki blues for Harry and his friends. Harry could have been a professional bouzouki player. Paris spent forty years as a professional drummer and pianist. The blues are in their blood.

Harry was born in the Patras region of Greece, an area rich in mythology, and though he moved to Montreal when he was seventeen, his heritage has shaped him and continues to do so. "I didn't come to Montreal by choice—I was sent here," says the wiry Harry, running his hands through his thick mane of curls. "It was impossible to make a living in my village. I had been working while going to school since I was twelve. For two years, I worked as a presser in a textile factory. It was so hot in there I couldn't even breathe."

So his family sent him to Montreal. He had no immediate relatives here, but he had an aunt in upstate New York, who would send clothing and money. Harry's first job in Montreal was as a pizza-delivery driver. After a few years of shlepping pizza to everyone from Brian Mulroney to blue-collar types, he switched gears a little and drove a cab for the next ten years. "That was my real education. You really get to learn about the city and the people who live here driving a taxi. It was an eye-opener."

To let off steam, Harry and a few buddies would go to the Blue Bonnets racetrack at night. "It's where young Greeks would congregate back then," Harry says while tuning his instrument. "We would all pool our money and if someone won, we'd all celebrate."

After his stint as a cabdriver, Harry got his first taste of the restaurant business. He worked as a waiter at Milos, then at Molivos, Le Prince Arthur and Casa Grèque. But he remained obsessed with the ponies at

Chef Paris Darmas tickles the ivories and belts the blues
—the bouzouki blues!

Blue Bonnets—not from a gambling point, though. "I was familiar with horses growing up in Greece and was always fascinated." So he decided to spend whatever spare time he had working as a groom on a volunteer basis at Blue Bonnets. He did the grunt work, mucking stalls and brushing down the steeds. One owner then gave him the opportunity to run his five horses in practice for five miles every day—which he did for free. It was then that he decided he wanted to be a jockey—harness-racing division—at the track. In short order, he got his trainer's licence and then his driver's seat. And at thirty-eight, he realized one of his life's ambitions, racing horses.

It should be noted that Harry had married when he was nineteen, and so between waitering and the horses, he had two sons to raise: Terry, now the hustling, James Dean-like maitre d', and George, the soft-spoken chef at Philinos. "It's funny," says Harry, still tuning. "I'm not really a businessman at all. I function more as a philosopher and an artist. Who knows? Maybe that's the reason this place does well. Because I know my place."

True to philosopher form, Harry's mind tends to meander. Back to the track he goes: "I never really had a decent horse. Not too many winners, either. I lost a lot more than I won. But to me it wasn't about winning and it wasn't about the money, which is just as well since I never made any there. It was all about the horses." Then one day at the track he had an epiphany of sorts: "I started to see the fear in the eyes of the horses. I was part of the problem, a driver whipping the horses to get the most out of them. I soon realized I cared for the horses much more than I did for the people at the track." Harry continued racing until he was fifty-two and still exercises racehorses, all the while refraining from whipping them.

Meanwhile, his waitering wages proved to be significant and enabled him to open his own place, Harry's Café, on Park Ave. Business got to be too brisk for such a small venue, so Harry opened Philinos in 1996. "My intention was still to have an intimate place for musicians and artists to come hang out and to play." What he didn't envision was that this formula would result in his place being elevated to hip terrain—Greek taverna category, that is. He takes it all in stride. "Success can easily lead to failure," he says. "I take nothing for granted in life. There's

no real secret to success. People seem to like this place. I can't explain it. Maybe it's because we tend to focus a lot on fish and vegetables and avoid heavy, greasy, fattening foods. The menu is a reflection of the food I eat. Older Greeks go for the heavier stuff, but younger Greeks go for this. Or maybe it's because the place already had good karma before I came." He pauses. "I am who I am. I won't change."

Harry does acknowledge he learned a lot from working at Milos, the most elite Greek resto in Montreal, and from consulting with its visionary owner/creator Costas Spiliadis, who has also made it in Manhattan with another high-end eatery. "Greek cuisine is basically very simple. Garlic, oil, lemon and oregano are the basis for everything. Keep it simple. Keep it fresh. That's about it."

Harry and his wife live in Laval. The kids are no longer kids. George is happily married with two of his own children. Terry the playboy is twice-divorced and the doting father of one young daughter, but otherwise shows little signs of wanting to settle down—much to his dad and mom's chagrin. Of course, Harry's far from sedentary himself. "I can't stay at home. I have to keep busy and talk and play my music all the time. Fortunately, I only need a few hours sleep a night," he says. "Kids today also have a lot of energy, but they don't have their values figured out just yet. They're beautiful, but they're still trying to find themselves. It took me long enough, so I understand. In fact, I think I'm still looking, and I'm not sure I have really grown up." Indeed, despite his years, Harry still maintains a childlike innocence. But there's no affectation here. It truly is the real deal.

Harry recharges his batteries by returning to his homeland for a few weeks every summer. "I have lived longer in Canada and am probably more Canadian than I realize, but I have such beautiful memories of my Greece. We lived in such poverty, but we lived rich all the same. In my wildest dreams, I never would have thought I'd end up here today with a restaurant. Like I say, I've been up and I've been down a lot already. It's taught me to be ready for anything."

Greece was also the breeding ground for Harry's passion: bouzouki music. "Growing up, that's all I listened to. It was the music of the proletariat. Greek blues, I call it. It's the music that will always lurk in my soul. It's my form of meditation. It's my therapy. I don't drink. My music is my only addiction."

His best buddy, Giorgos Bratis, a philosopher/artist/poet/singer, can vouch for that. Bratis, also on hand for the bouzouki blues session, goes back thirty-five years with Harry. And like Harry, Bratis also got into the restaurant trade by accident. He had an art gallery downtown and, in the course of his business, hooked up with the owners of the Casa Grèque chain. "They knew I was struggling with the gallery, so they offered me a job at one of the restaurants," Bratis says. "I told them I knew nothing about the business. They said all I would have to do is be a host in the front, smile and greet customers in French and English, as well as Greek. One thing led to another, and I was soon managing a restaurant for them."

Harry and Bratis had recently planned on opening a Philinos branch in the Grenadines in the Caribbean. But life got in the way. A week before they were to set up the operation, Bratis's brother, a professional motorcycle racer, died in a freak, non-racing motorcycle accident in Greece. Now Bratis is heading back to his native land to help out his aging mom. Bratis has bought himself a boat, and plans to pursue his greatest passions while there: painting and fishing. And, of course, philosophy.

"I will return to Montreal, though," he pledges. "It is my home now. Harry is my soul brother. And, oh yeah, my wife is here, too." Pause. "I've been through thick and thin with Harry. Like when he opened Philinos, and he had to sleep in the basement for the first six months, because he was so cash-strapped that he couldn't afford a car to drive back late at night to his home in Laval. But now he's a success … in spite of himself," Bratis cracks. "And to think we were once two young Marxists who wanted to change the world. We still do, but we've also come to terms with the reality of trying to provide for our families."

Brother Paris, still sporting his chef's smock, has slipped out of the kitchen and is ready to tickle the ivories. Dimitri Kanaras has ambled into Philinos too. A thirty-year-old chef at the Greek eatery Mykonos in Montreal's Notre Dame de Grâce neighbourhood, the ruggedly handsome Kanaras could pass as a matinée idol. He has no interest in the fast lane. Married and the father of a baby daughter, he has the same passion as Harry: bouzouki blues. Harry says Kanaras is one of the best bouzouki pickers in this or any other town. Kanaras also plays

traditional guitar and has performed with a number of Montreal rock and blues ensembles. "A lot of people can master regular guitar, but you have to be a virtuoso to master the bouzouki and to play the blues," states Kanaras, who has been playing since he was eight.

Harry's brother Paris started cooking - music-wise—when he was six. He can play virtually any instrument anyone throws his way. Harry says he has the gift. Paris's instrument of choice is the drums. Before settling down as a cook, he performed at hotels and clubs and theatres around the world. "But the travelling just drained me and took a toll on my private life," says the divorced Paris, who's as wiry as his brother. "Now I play for the love of the music and that suits me fine. I am as content playing drums as I am playing piano or violin or bouzouki." For the record, Paris can also perform wonders with swordfish and sea bass. "And to tell the truth, cooking helps me avoid the musical pollution elsewhere," he says.

Time for therapy has come. While Paris plays something on the piano bordering more on classical than traditional Greek, Harry and Kanaras start strumming their bouzoukis and crooning. Bratis adds his deep tenor to the proceedings. Think of the ensuing sounds as something akin to Greek Delphi meets Delta blues. The passion is heartfelt. The players are entranced. The audience of waiters and hangers-on is also entranced. Some are bopping to the bouzouki beat. Others are singing along. Those without instruments are deliriously clapping their hands. It's infectious. The setting could be Athens or the Greek islands, for that's where the music transports us.

The song is over. Kanaras reflects: "I used to play professionally. But there was such uncertainty in the business. Sometimes you make money. Sometimes you lose. Now I play music just for the love of it, and that suits me fine."

Paris plays the role of philosopher too. "Music can come from the heart or it can come from the mind," says Paris, who studies music theory at McGill University's Faculty of Music in his down time. "For me, though, live music must come from deep down in the heart."

Now entering the fray is Yianni Bourdos, who works as a waiter at Casa Grèque both day and night, and sings and plays bouzouki when time permits. "He's a modern Ulysses," Harry says of Bourdos, one of his closest friends.

After moving to Montreal when he was eighteen and spending the last forty years here, he is returning to his native Ithaca to care for his ailing mother. Bourdos swears he will return to Montreal. "I love this city—except for the winter," he says. "I just want to take it easy for a little and watch the olive trees grow. It's easy to lose sight of what you really want in life."

Kanaras has little doubt that Bourdos will return here. "Montreal is like a mistress. No matter how cruel she can be, you just can't stay away from her. You end up always coming back to her." The "cruel" part, one would have to surmise, is winter.

Quietly taking in the music and talk is Helene, Harry's attractive blonde wife of thirty-six years. "Helene is my rock. She has supported me in every which way. She has encouraged me to pursue my dreams. She is so wise. I would be nothing without her."

Bratis nods. Helene nods, then adds with a smile: "Harry is his own person. He can't be harnessed. He has to be allowed to fly free to succeed."

Harry is all smiles: "I'm so very happy now. I'm in my element, talking and playing with friends. And yet I feel so guilty about being this happy when I look at the suffering around us. This is what I grapple with all the time. This is what keeps me up at night." He sighs. "All one can do in this life is plant the seed. If it is done right, it will grow."

[Philinos, 4806 Park Avenue]

4:00 a.m.

"THE NIGHT IS NOT OFFICIALLY over in Montreal until people pass through the doors of Boustan." So sayeth the prophet Imad Smaidi, the ever-beaming, beanpole proprietor of Boustan. Sure, Smaidi may have a vested interest in making such a proclamation. But he ain't far wrong. They come from far and wide in the wee hours as well as the rest of the day to devour what is unarguably the best shish taouk in the city. Sorry, the best chicken shawarma in the city ... but more later on Smaidi's crusade to use the proper appellation for this mouth-watering, Middle Eastern delicacy.

It's 4:17 in the morning. Boustan is perhaps too brightly lit for the hordes who have descended upon this basement oasis of fast food, especially since many among them might be hung over from an evening of revelry. The hordes come in all sizes and ethnic backgrounds. But they are mostly under-thirty club kids, evenly divided along gender lines. Some are dancing to the music, an eclectic mix of pop and traditional Arabic tunes. Some are scoping the TV for sports scores. Some are checking their Blackberries and laptops for text messages and emails—for Boustan is fully WiFi for this Internet age. All appear to be famished.

"They are like my children," says Smaidi, who has three of his own—two sons and a daughter who also work at Boustan. "I know 90 per cent of them by name and I know almost 95 per cent of the time what they will order—even before they know, sometimes." Which makes sense, considering that after much partying some customers are not too swift at relaying menu messages from their cerebrums.

Boustan will stay open until the last shreds of chicken on the spit have been shaved onto some toasted pita. This generally turns out to be at six in the morning. But this is not when Smaidi goes for a little shut-eye. After cleaning up and closing the place, he heads off to the market

to purchase produce for the coming day. He will catch a few zzzzzs around ten in the morning and he'll be back behind the Boustan spits around four in the afternoon. Most resto owners, given a choice, would work a day shift and delegate kin or trusted employees to man the place at night. Not this fifty-year-old shawarma-meister.

"I must be here for the kids. I must make sure they eat properly and get home okay. This is my mission." Well, one of them, anyway. This is a man of many missions.

It's not just the young and restless club kids who've made Boustan a regular pit-stop. Canadiens hockey star Mike Komisarek and his buddy, ex-Hab Michael Ryder, as well as the Habs bosses, the Gilletts, are regulars. As are members of the Alouettes football team. And rock stars and movie stars and models. And before some of Boustan's customers were born, Pierre Elliott Trudeau, after his stint as Canada's prime minister, was a frequent visitor. Not just for the grub, either. Trudeau and Smaidi, who was born in Beirut, would discourse on politics and prospects for peace in the Middle East and, yeah, hockey, too. Now the torch has been passed, and the late Pierre's son Justin Trudeau makes regular pilgrimages to Boustan.

Justin's visits tend not to be of the extreme-nocturnal variety— unlike those of Elspeth Garland, one of Smaidi's favourite customers. A model/student/barkeep/cut-up, the willowy Garland can be counted on to show up at this hour, like clockwork, after her bartending gig across the street at Karina's. In fact, Garland is so familiar with Smaidi and the staff that she helps herself behind the counter to plates of potatoes and hummus and falafel. She'll even pick up the phone to handle takeout orders, and insists she's actually made a few deliveries, too.

"I come here for the murals on the wall. Okay, that's not entirely true. I love this man. I love his guts," says Garland. "He's like a father to me. He encouraged me to go back to school to get a degree. And when I did, he was in tears and he hugged me. I know it sounds corny, but he puts the same love in his food." Garland is encouraging her buddy, Lindsay McKussky, a stalwart with the Concordia Stingers women's hockey team, to try the specialty of the house. So special, it's not even on the menu. It's called the Creation Sandwich, and it is said to be so heavenly that those who have consumed it have had divine hallucinations.

The Creation is a combo of chicken and potatoes and eggplant and an omelet and hummus and hot sauce and salad and the special Boustan sauce, all stuffed into a pita and then perfectly melded in a sandwich press for a minute or so. At five bucks, it's a steal, and it is, without question, heavenly. Smaidi still knocks back a couple of Creations every day.

"I don't need government food inspectors here," Smaidi declares. "My customers are my inspectors, and are more demanding. That's why my food quality can never slip."

Meanwhile, Garland is behind the counter making a Creation. "Now, that's trust, right?" she asks. That it is.

This is Garland's story: "Once upon a time, there was a princess called Elspeth. A lot of people had trouble spelling her name, but she was the best thing to happen to this city since … your religious leader of choice. But Boustan bomb diggs!"

Smaidi is not certain how to react to "bomb diggs," particularly since bombs are a sensitive subject for him, having grown up amidst them in Beirut. But after Garland explains the expression is meant as "props" to the man they call Mr. Boustan, and to his "peeps" and his food, he accepts her compliment with a gracious smile.

Smaidi is often asked to franchise Boustan around the city and the country, but he fears that without his personal, hands-on touch, success might not be replicated elsewhere and his good name could suffer. "My goal is to become the Lebanese Schwartz's," he says, not unaware of the confusing signal that could send to some. "People have wanted to set up Schwartz's franchises, too, but the owner also worries about quality control, that his smoked meat might not live up to his high standards elsewhere."

Schwartz's owner, Hy Diamond, is fond of saying that there is only one Carnegie Hall, one cross atop Mount Royal and one Schwartz. Smaidi can relate to that mantra and adds Boustan to the equation as well.

It's been a long and circuitous road for Smaidi. He was only nine when he was orphaned in Beirut and had to fend for his four siblings. His dad died after a heart attack. His mom died in a car crash a few months later. He had no other close relatives. Smaidi had to work while

going to school. At thirteen, he could no longer keep up with his classes while trying to provide for his family, so he quit school. Fate, fortunately, intervened. One of his employers was so impressed with Smaidi's determination that he subsidized his attendance at the same private school as his own son. After a slow start, Smaidi began to ace all his courses and even tutor the fellow's son. After high school, he went to a military college for three years and became a policeman in Beirut upon graduation.

"Then civil war broke out in Beirut in 1976, so I decided to leave Lebanon for Canada. My brothers and sisters also dispersed to Dubai and Brazil. I knew no one here, but decided to embark upon my dream of becoming an engineer." To that end, he studied at L'Ecole Poly-technique in Montreal and became an industrial engineer. He worked for Phillips, the mega electronics company, and rose through the ranks to senior management, before deciding he'd like to try his hand at operating a Lebanese restaurant. "Today, there are dozens and dozens of Lebanese restaurants in the city, but back in 1986 there were only four. I figured it was worth a shot."

He figured correctly. "Now one of my goals is to change the name of Crescent to Boustan Street," he says, with a huge grin. "This is a goal, of course, that I will never see come to fruition, but it's nice to dream."

Another of his dreams is peace in the Middle East. Smaidi, a devout Muslim, caters not only to his co-religionists, but also to every other religious group in the city. "Good food knows no religion," he declares. "Some of my most loyal customers are from the Jewish high school Bialik. When they asked me to help them with an economics school project to set up a small restaurant counter in their school, I was honoured. I bought all kosher food and equipment for the project. The kids made $1,800 in three days and won first prize at their school. Then they went on to win a provincial prize, too."

In order of priority, Smaidi announces his current life missions: 1) world peace; 2) Crescent Street's name being changed to Boustan; 3) the Stanley Cup returning to Montreal annually—"which could even be more of a long-shot and take longer than the other two goals," he cracks.Oh, yeah, and can't forget his mission-du-siècle, chicken shawarma.

The normally genial Smaidi veritably bristles at the mention that his shish taouk is considered by many to be the best in the city. It's not the rating that irks Smaidi. It's the name. "Please," he implores. "Call it its true name: chicken shawarma. This has gone on too long."

Smaidi is correct. Let's get etymological for a moment—it won't hurt a bit and doesn't involve any shedding of clothing. So what is a shish? Or a taouk? Or a kebab, or a shawarma? A shish, simply put, has its origins in Turkish and means skewer. Taouk, also Turkish, refers to grilled or roasted chicken. The so-called shish taouk that most Montrealers devour at the city's many Lebanese restaurants is not chicken grilled or roasted on a skewer. Rather it is a mass of tantalizing morsels of boneless chicken—marinated in olive oil, lemon and garlic— which are shaved from a vertical roasting spit, and served either on a plate or on a pita, laced with garlic mayonnaise or, preferably, hummus, and garnished with a variety of vegetables, peppers, pickled turnips and tabbouleh.

Shawarma, on the other hand, is an Arabic term essentially referring to the process for cooking beef or chicken on a vertical roaster. Thus, chicken shawarma would be a more accurate term for what is commonly referred to as shish taouk, much as Lebanese restaurants in the city list beef shawarma on their menus.

However, if we choose to get overly etymological, shawarma, according to some foodie-history buffs, is a delicacy that originated in Turkey under the name of doner kebab, although kebab generally refers to grilled or roasted meat.

Yet, no matter where one goes, shish kebab is served as chunks of grilled meat, often accompanied by veggies and invariably served on a metal or wooden skewer. Of course, shish kebab is not to be confused with kafta kebab—minced beef with parsley, onions and spices. In the interests of accuracy, let it be noted that the word kebab is thought to have been derived from Akkadian, an extinct east-Semitic language from ancient Mesopotamia—now Iraq and Syria—and the earliest surviving kebab recipe goes back to ninth-century Baghdad.

To avoid triggering further culinary vocabulary wars, we won't even attempt to delve into the origins of gyros and souvlaki now.

Smaidi the purist has only "chicken shawarma" signs at his

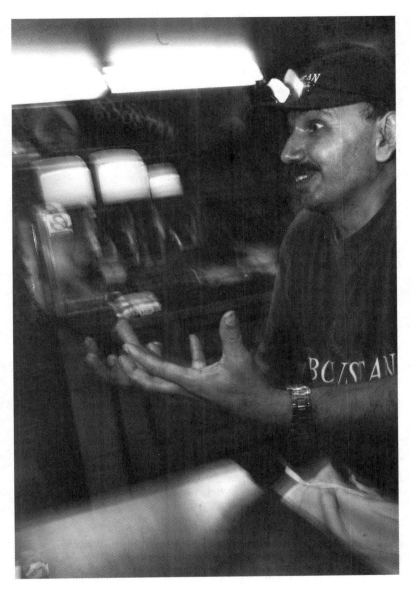

Mr. Boustan!—Imad Smaidi.

establishment; however, until early in this millennium he too had always listed it as shish taouk. "About five years ago, tourists starting coming into the restaurant and asking for shawarma," recalls Smaidi—whose shish taouk, er, chicken shawarma, was voted second best in the city, after the Amir outlet on l'Acadie Boulevard, in a *Gazette* taste test some years ago. "We would serve them our beef shawarma. They would say they meant chicken. There would be arguments."

So Smaidi went on a fact-finding mission back to Lebanon. He couldn't find shish taouk anywhere. But he did find chicken shawarma there and just about everywhere else in the world. "If you go into a Lebanese restaurant in New York or Toronto and ask for shish taouk, they'll probably ask you if you're from Montreal," Smaidi claims. Turns out we Quebecers can once again pride ourselves on our distinctiveness.

Boustan's competitors don't disagree with him: Peto, an employee at a downtown Amir location, understands the distinction and knows that elsewhere the dish is called chicken shawarma; still, he doesn't believe his restaurant will cease calling it shish taouk.

Abdallah Akkouche, one of the guiding forces behind the Basha restaurant chain, is actually credited for both creating shish taouk and coining its name here. "They weren't even making it in Lebanon when I left," he says. "I know what shish taouk really means, but that's the name that has stuck with us and with our clients, and we have no plans to change it."

Smaidi understands: "Although most Lebanese know shish taouk means chicken on a stick, they just accept the name here. But I can no longer just sit still. The truth must come out." Rest assured that Smaidi is no shawarma zealot. He can be quite the kibitzer. He gets much more fired up talking about his beloved Montreal Canadiens.

If he ever does expand, Smaidi pledges to offer the same free Internet access in the new outlets. In fact, Smaidi picks up one of his portable computers, goes to Google and searches for—you guessed it—chicken shawarma and shish taouk. And Google reveals 46,300 hits for chicken shawarma plus another 16,400 for chicken shwarma, but only 12,900 hits for shish taouk. And Smaidi is more than willing to say he told you so.

Oh, and lest we forget, Smaidi works his daunting eighteen-hour

day seven days a week. "It's tough because I don't get to see my wife often, except sometimes at work," he says. "On the other hand, that's probably why we're still married."

Smaidi estimates that he has taken off only thirty days in the last twenty-one years, including two trips back to Lebanon and one hospital stay for a knee operation. "I love Beirut, but I love Montreal even more. It's my home. These are my people. I feel so safe here. I know if I ever fall, someone will pick me up."

And when he did fall and require an operation on his knee, he got picked up—metaphorically speaking—when he awoke and discovered that the attending nurses and physician were regular customers. "After making sure I was okay, two nurses asked: 'Mr. Boustan, could you please order us a few chicken sandwiches? As soon as we saw you here, we started to get so hungry.'"

Customers are beginning to drift out of Boustan. Sunrise is not far away. "I didn't realize it until now, but I've actually worked the last 42 hours straight. My customers give me energy, especially when they smile. I'm sure we've long passed the one-million-pitas-served mark. But the pressure to maintain standards is also too much at times. People come in here from all over the world, and I don't want to disappoint. I want to surpass expectations. You can't live on your reputation."

Smaidi is fully aware that, in this game, you're only as good as your last shish ... er ... chicken shawarma. "I went for a check-up recently, and my doctor tells me to keep doing whatever it is I'm doing. I told him: 'Screw you! I hoped you were going to tell me to slow down. I'm working eighteen hours a day. Keep doing what I'm doing? Thanks a lot!'"

It's 4:53. A customer walks in. Smaidi nods and prepares him two Creation Sandwiches. "He doesn't have to ask. I just know what he wants. And when I don't, they never complain about what I serve. Pierre Trudeau stopped ordering at the end. He would just tell me: 'Boustan, bring me whatever you want.' He could be a demanding man. That was the ultimate compliment." Big sigh. "Maybe I should change my name to Boustan. Now even my family thinks that's my name."

Talk about brand marketing.

[Boustan, 2020 Crescent Street]

5:00 a.m.

Raja Thamthurai is boppin' to the beat. The bagel beat. It's 5:02 a.m. and Thamthurai is doing what he has done the last nineteen years at this hour. He's getting his daily shvitz—steam bath—in front of the 400-500 degree Fahrenheit wood-burning oven at Fairmount Bagel. He mans the long wooden paddles on which sit dozens and dozens of bagels, most of which will be consumed within a few short hours in the city where the bagel is supreme.

Montreal may have lost its supremacy in everything from national head offices to hockey championships. But, damn, no one can touch our bagels. And no one can touch the bagels of Fairmount or its cross-Mile End rival, the St. Viateur Bagel Shop. Not that they haven't tried. There are dozens of would-be bagel kings in Montreal wishing to wrest the crown from Fairmount and St. Viateur. And there are even upstarts in Toronto and Hamilton who have the unmitigated chutzpah to suggest their rolls with holes can proudly carry cream cheese and lox like our bagels. The argument should have been forever put to rest after a blind taste-off in 2006 between Montreal and Hogtown's best, in which the latter's cement-like depth charges were dismissed as sorry pretenders by a panel of *Montreal Gazette* and *National Post* journalist judges—including this bagel devotee. The prevailing view was that those Toronto bagels might better serve as hockey pucks. History repeated itself in another taste-test in February 2008, when a a couple of batches of bagels from Steeltown—more like paperweights—proved no match for the best from Montreal.

Not sure what music Thamthurai is listening to through his head-phones. But it keeps him hoppin', and clearly keeps his mind off the sweltering heat of the oven. There is no respite here. The sun has yet to rise, yet folks are coming in from all corners of the city for their bagel fix. Taxi-drivers and what Thamthurai calls "party people" end their

evenings of work and revelry on a sobering bagel note. Then there are the factory workers and brokers and resto-owners starting their days with a bagel nosh.

"I lose all concept of time at the oven," confesses Thamthurai, who moved to Montreal from Sri Lanka twenty-five years ago. "That's probably just as well." Probably, since he does the ten p.m. to six a.m. graveyard shift. "In my wildest dreams, though, I never would have imagined when I was a child that I would end up baking bagels. People say I should be proud, because I am performing an important service."

Lowie Magdaluyo is chipper behind the counter, handling the steady stream of customers. She works an even more daunting seven p.m. to eight a.m. shift—by choice. "I have trouble sleeping at nights," she says. "I prefer daytime for sleep." She also has a confession. Prior to moving to Montreal from her native Philippines a decade back, she had never seen, much less heard of, bagels. "But I'm making up for it now. I love them, like I love this city. It's just winter I hate. But I do have the oven here to keep me warm."

Though purists may bristle—because, in their minds, only the sesame and poppy-seeded white bagels matter—Magdaluyo has really gotten into the whole-wheat power bagel with raisins, while Thamthurai opts for the cinnamon variety.

There is no question, though, what Nick Noik prefers. He has been sent on a mission by friends and family to bring four dozen sesame-seeded bagels back to Toronto. An ex-Montrealer, Noik is doing what he is hoping will only be temporary penance in T.O. but he hasn't forgotten his roots. It's 5:11 a.m. and he is about to head down the 401 with his Toronto girlfriend, Stephanie Goren, who has naturally learned to love Montreal bagels.

"Oh, they can try all they want in Toronto to replicate the Montreal bagel, but it's futile," says Goren. "This bagel rocks."

"Everyone says it's the Montreal water responsible for the great taste," says Noik. "So, I'll go along with that, too. I'll also go along with the notion that I may have lost at the city's casino last night, but I'm always a winner here." Whatever gets you through the night, dude.

Noik is so enamored of these baked goodies that he even named his dog Bagel. And betting man that he is, he figures he and Goren will

have polished off a dozen of the four dozen bagels by the time they hit Kingston, only halfway back to Hogtown.

Neil Diamond has just ambled into Fairmount Bagel. He is hardly the first big name to grace the place. Okay, so this Neil Diamond is not the famed crooner, but rather a filmmaker shooting a documentary about the mapping of Labrador. He is about to embark on a lengthy plane ride to the north of this province with his cinematographer Edith Labbé, and they both know what they want to munch on during their trip. "There are people waiting for us and let's just say they feel our mission is to bring bagels to Ungava Bay," muses Diamond, who saves his singing for karaoke.

There are those who swear Fairmount makes the best bagel. And there are just as many who swear St. Viateur is No. 1. "There is no real rivalry between us," says Fairmount owner Irwin Shlafman. "They have their devotees; we have ours. And that suits me fine." History may be on the side of Fairmount. Shlafman is the grandson of Isadore Shlafman who first brought the bagel recipe to Montreal in 1919 from his native Russia, and each successive generation of Shlafmans has been baking bagels since. The Shlafman mantra is: "We're bagel people. Bagels will always come before profits for us."

St. Viateur marked its fiftieth anniversary in 2007, and while the family of founder Mayer Lewkowicz is no longer involved, current owners Joe Morena and Marco Sblano have spent all their adult years and much of their adolescence learning and mastering the trade Lewkowicz introduced them to. Sales may be on the side of St. Viateur. Morena and Sblano have prospered and have seen their bagels show up at supermarkets across the province. And they have multiplied. There are two bagel outlets on St. Viateur Street, plus operations on Mount Royal Avenue and Monkland Ave., as well as ovens in two Esposito supermarkets.

"On any given Sunday, either St. Viateur or Fairmount could win in a taste-off, but we're both in a league of our own," Morena has proclaimed. "But I would have had to bury my head in the sand had Toronto won a taste-off against us."

It's 5:34 a.m. and co-owner Sblano has been in his St. Viateur St. office for over an hour. He will spend the next twelve hours on the job.

Fairmount Bagels

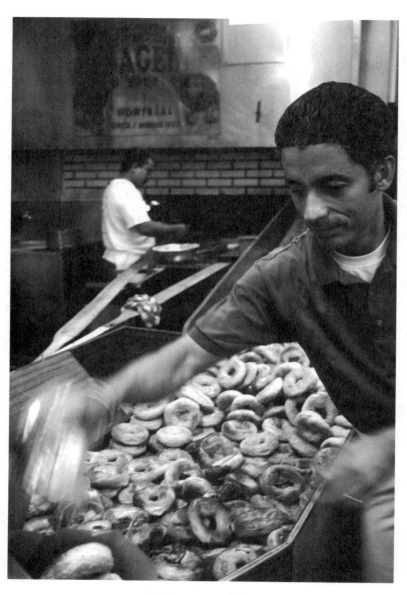

St. Viateur Bagel Shop

This has been his routine for more years than he can recall. He began in the bagel biz when he was twelve. That was thirty-five years ago. His first job was shlepping wood from the garage to burn in the oven. He quickly rose through the ranks, but he hasn't lost touch with the art of rolling and baking the perfect bagel—which he will still do in a pinch.

He estimates that this outlet will turn out 500 dozen bagels over the next twelve hours. And how many will be sold? "All of them, of course," says the soft-spoken Sblano. He's not being boastful. It's simply the reality. "Success is no accident. We continue to make a great product, because we continue to do it the old-fashioned way. No machines. No gas or electric ovens. Natural products. And no preservatives. It's simple."

What about the water? "People who come in from out of town say it's our water that makes the difference, but I say it's the flour and the sesame seeds as well," Sblano states.

As is also the case at Fairmount, St. Viateur serves an inordinate number of celebs. Céline Dion was an almost daily regular when she lived in the 'hood. And she and hubby René Angélil still show up whenever they're in town. But no one can top Harry Brown. The plumber has missed only a handful of working days here since the place opened in 1957. Like clockwork, he arrives at 5:40 a.m. "This is how my day begins, a fresh bagel with cream cheese and lox," he says. "Nothing has changed here. Except Marco (Sblano) was a kid in the early years and now he's almost the same age as me. Bagels have made me ageless."

Sblano is sporting his official St. Viateur Bagel Shop T-shirt. He wears it religiously. "St. Viateur is a national landmark," he says. "That's such a wonderful thing, yet there is also a huge responsibility on our shoulders, to live up to that reputation and to maintain the quality. The pressure is always on. We can't afford to slip up."

Sblano's wife Carolann, as well as his two sons—when not attending school—also work in the operation. "I can not tell a lie: bagels have been very good to me," Sblano says.

Saul Restrepo has worked alongside Sblano the last twenty-six years. He handles the baking in the wee hours of the morning. Nor has he lost his appetite for bagels over the years. His favourite is a bagel with

old cheddar gently melted in the oven while he's working.

Despite the high heat of the oven, the place gets nippy during the winter, what with the constant traffic and the opening of the door. "It got so cold on some nights years ago that a few of our regular women customers had to come in wearing big fur coats," Sblano notes. "Of course, they didn't have anything underneath their coats." The women were ... ummm ... exotic dancers from the former Sextuple strip bar.

The St. Viateur Bagel Shop is also known to many as the Bagel Factory, although no one is really sure how that name emerged. But there can be no doubt that it churns them out like a factory. How many? "Just over 25 million bagels a year," says Sblano.

That's a lot of dough.

Like Fairmount, St. Viateur had to cave in a little and start producing cinnamon and nine-grain bagels to meet the demands of its diverse clientele. "Tastes have changed," Sblano says. "In the early years, the poppy-seeded bagel was far and away the most popular, but now the sesame-seeded bagel accounts for 90 per cent of our sales. Personally, I prefer a bagel with no seeds."

Sblano allows that the bagel biz has been an education. He can converse in English, French, Italian, German and even Yiddish. It's 5:48. Philippe Tremblay, a filmmaker in the middle of his day, races in for his daily fix. "It's a Montreal tradition —no matter what time of day, 24 hours a day. It's nice to know a hot bagel is always waiting for me."

George Panitsas, who owns the nearby Café Java Mythe, comes in for his regular order of five dozen. "This is the best bagel in Montreal, and therefore the best in the world," he pronounces. "This is what makes Montreal tick."

"It also helps that the city is relatively clean and safe enough to walk around in, even at this hour," adds Sblano.

Or to skateboard around in. Another regular, Terry Kell, has just rolled up on his board. Born in Quebec City, Kell uprooted to Montreal, with board, some twenty years ago. He earns his daily bread—or bagel— playing infectious music on his trusty dobro at downtown métro stations. "They call me the Lone Dobro, probably because I'm one of the only dobro players around," says the long, lean Kell, sporting a

leather jacket and with the hood of his sweatshirt covering his head.

"What I love about this city is that you can find anything you're remotely curious about here—even a dobro player," declares the smiling Kell. "Oh yeah, they also call me the King of Jarry Park, and not necessarily because I'm the best boarder at Jarry Park. But because, at forty-three years old, I'm the most kingly boarder at Jarry Park."

And, chances are, the only one at Jarry Park who can board and knock back a bagel at the same time.

[Fairmount Bagels, 74 Fairmount Street W. —
St. Viateur Bagel Shop, 263 St. Viateur Street W.]

6:00 a.m.

THERE ARE MOUNTAINS of cartons of cauliflowers and carrots and broccolis and tomatoes and eggplants and green peppers and red peppers and yellow peppers. And then there are the endless boxes of fruit. It's 6:04: the sun is about to rise. But already risen are scores of chefs and store-owners and distributors scouring the loading docks of Marché Central in search of not just the best veggies and fruits, but also the best-priced. As is their custom, farmers from the countryside around Montreal have descended on this vast market to unload their goods and to engage in some time-honoured bargaining.

The early bird may get the worm. But the buyer who lingers invariably gets the best deal. Action this morning at Montreal's answer to the Casbah has been fast and furious. Mario LeFrançois is still smiling. That's a good sign. He's been up since way before the roosters and still has another two hours left in which to sell the remaining cartons of eggplants, peppers and zucchinis. He arrives here from his farm in St. Rémi and lays out his wares around four a.m. He has been doing this the last fifteen years through spring, summer and fall. He is particularly known for his zucchinis. In winter, he changes métier and does snow removal in the city.

Four a.m. is also when Mylène generally arrives at Marché Central, to buy produce for a market in Ile Bizard. She gets up around two a.m. every day to drive into the city, purchase the stock, load it into her truck and drive back to set up shop. She has been following this routine the last twenty-five years through spring, summer and fall. She knows all the producers and they know her. "It's really another world here, but it's my world," she says. "This is the only place to come for fruits and vegetables. These are my people."

LeFrançois has ten cartons of eggplants left. Mylène likes them. She knows he would like to sell them before he heads back to the farm.

At this time of the morning, it's a buyer's market. And this buyer is ready to do some business with this marketer. "I don't have to pick the vegetables here any more," Mylène says. "I just pick the seller I know and trust.

Down the loading dock from LeFrançois is another regular, Pierre Trudeau. "There's no E for Elliott," he blurts out, lest you confuse his name with that of the late Canadian prime minister. Broccoli, not biculturalism, is this Trudeau's game. He lives and dies by his broccoli.

"They could call this place Marché des Fous," he cracks. "People can get really crazy here, because of a lack of sleep."

Trudeau has been coming in from St. Constant for the last fifteen years. "It's hard work. I'm selling to the big hotels, restaurants and supermarkets. They all want the best and they all want the best price. Competition is crazy. But I know I have the best broccoli around, and so do the buyers. So we usually reach an agreement that's good for all of us."

Trudeau would like to spend more of his waking hours with his sons and wife, taking in hockey games and festivals in Montreal. "But work comes first. I never thought that my life would revolve around broccoli, but it does." Trudeau is somewhat circumspect when it comes to talking about how he feels about eating broccoli. It's understandable.

Beleaguered though he may be, Trudeau and the others in the area come to life when they spot the diminutive Peter Mourelatos, the seventy-three-year-old founder and proprietor of the Mourelatos mini-empire of four supermarkets. For fifty-one years, he has been coming to this market and those that preceded it to stock his stores. He's been doing it seven days a week. He gets up at two, hits Marché Central at four, buys the produce, then loads it and drives it off to his four stores, where he spends the rest of his day, flitting from one to another. He closes the last store at nine p.m. before taking his four-hour sleep.

"I don't need a lot of sleep," he says. "This is the highlight of my day. Coming to the market and looking at and smelling the vegetables and fruits. I don't trust middlemen distributors to pick for me. I know what I like and I know what my customers like."

He picks a cauliflower out of a carton. First he looks it over. "You can tell by how white and clean it is whether it's likely to be good. But

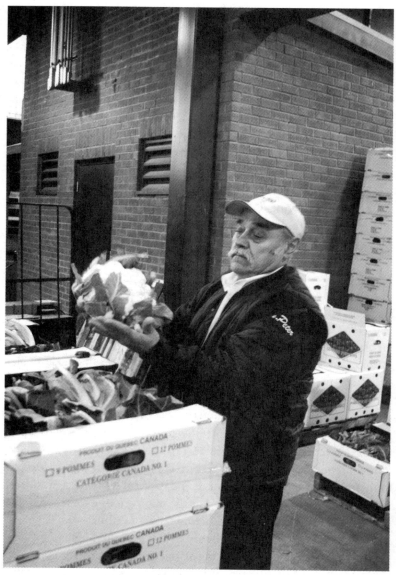

Peter Mourelatos at Marché Central.

you don't really know for sure until you smell it." Apparently this one pleases his knowledgeable nose, because after sniffing it he gives a thumbs-up. "This is a thing of beauty, isn't it?"

But Mourelatos confesses that even he can be fooled. "I have to be especially careful about peaches and nectarines. They can look and smell good, but they can also be bad at the core. It's a tough business. You can't afford to mess up. Just one bad batch of fruits and vegetables can destroy your reputation and your business," he explains.

"This is such a competitive business, too. There are so many grocery stores out there. Margins aren't great. We're competing against huge chains. Success depends on my ability to find the best products at the best price. It's a crazy business, but it's the only business I know." Much as it is for LeFrançois, the zucchini man, and Trudeau, the broccoli man.

"Still," Mourelatos adds, "I wouldn't change my life here for anything in the world. I may have grown up in Greece, but now my heart is in Montreal."

Mourelatos was only eighteen when he arrived here in 1952. "I didn't speak English. I didn't speak French. Even my Greek wasn't that great," he muses. "I had only five dollars in my pocket when I got here, and started working at a bakery for thirty cents an hour. Not much, I know. But I worked all the time and saved all I could. And somehow I managed to open my first store four years after coming here. I haven't stopped working since and don't plan to, either."

Mourelatos has moved on to red peppers. He looks. He feels. He smells. He says little. The vendor says the price is ten dollars a carton. Mourelatos says he'll take 50 boxes at $8 each. The vendor mulls over the offer a few seconds and agrees. "That's an offer he couldn't refuse," Mourelatos says. "But that's the nature of the business. I understand his needs and he understands mine."

Mourelatos has two sons and a daughter working with him— though clearly not here and at this hour. "Young people today—they don't get up at two in the morning to start work, and they don't often finish at nine at night, either." He laughs. "Even if they set the alarm at two and it would go off, they still wouldn't get up." Big laugh again. "Me? I don't need any alarm. I get up at two automatically. And I will

do this for another fifty years. My mother lived until she was 107. I plan to surpass her. And I plan to go out working all the way."

The red-pepper vendor, who is probably half Mourelatos's age, offers to help him load the fifty cartons onto his truck. Mourelatos won't have anything to do with that. "I need the exercise," he says with a smile. "I'm still young enough to do this. Next thing you know, someone will ask if they can drive my truck for me, too."

Trudeau, the broccoli man, just shakes his head in admiration. "They don't make them like him any more," he mutters.

That they don't. And not that they ever really did.

[Marché Central, 815-A Chabanel Street W.]

7:00 a.m.

IT'S 7:02 IN THE MORNING. La Banquise is packed. People are eating poutine.

Let me repeat that: It's 7:02 in the morning. La Banquise is packed. People are eating poutine.

What's wrong with this picture? Nutritionally, ummm ... pretty much everything. But try telling that to the young couple coming off an evening of high revelry and tequila. "This is the ultimate hangover-killer," claims Solange, a student who would otherwise probably have a hard time attending law classes three hours from now. She is chowing down on the Poutine Dan Dan, an amalgam of pepperoni, bacon and sautéed onions atop melted cheese curds, french fries and gravy, and she is certain that with that under her belt she can hit class without benefit of sleep.

"Of course, my breath might not smell so good," she adds. "But that's the price we pay to have it all."

Her mate, Jean-Luc, is a high-tech type who keeps his own hours and his own counsel. He goes for the gusto: the large T-Rex poutine, a combo of hamburger steak, pepperoni, bacon and smoked sausage over the cheese, fries and gravy base. "This is the way to end the day," he declares. "Or to start it. I'm really not sure if I'm finishing or starting it."

Besides the night owls capping off their outings with poutine, there are, rather bizarrely, people actually starting their day with a poutine breakfast. On the other hand, it must be said that some of the newly risen are ordering the more traditional bacon-and-eggs fare.

La Banquise is one more piece of what makes Montreal so darned distinct. This hip Plateau poutinerie, adjacent to Lafontaine Park, is open 24/7. Montrealers and tourists in the know go to Schwartz's for smoked meat. They go to St. Viateur or Fairmount for bagels. And they go to La Banquise for poutine. At forty, La Banquise is among the

oldest poutine outlets in the province; it is arguably the best.

Between two and three in the morning, the lineups outside extend almost to the park. This isn't surprising in a city where nocturnal binge drinking is almost invariably followed by a high-cholesterol nosh—all the better to absorb the booze in the tummy and sweep the cobwebs from the brain.

Among those who make the pilgrimage to La Banquise are über-chefs Normand Laprise of Toqué and Martin Picard of Au Pied de Cochon, who are to the apron in Montreal as Anthony Bourdain is to it in the Big Apple. And wouldn't you know that even Bourdain himself has feasted on the poutine of La Banquise—he opts for the simple, unadorned Classic of curd cheese, fries and gravy—and he has extolled the virtues of this concoction to foodies around the planet. He was also left glowing by the foie-gras poutine that chef Picard offers at his own restaurant—a dish that may in fact owe its existence to the inspiring example of La Banquise.

Once ridiculed as nothing more than a high-calorie, high-cholesterol mélange for the masses, poutine has suddenly found respect outside the province where it was born. High-end restos from New York to Chicago, Miami to L.A., are now doing the Québécois meltdown, to the delight of customers. And cardiac arrest be damned.

Doubtless grinning from his final resting station is Fernand Lachance, the Quebecer reputed to be the Papa of Poutine. Though he passed away recently at the age of eighty-six, he reportedly feasted on his concoction up until the end.

Back down on planet Earth at La Banquise, those starting their days don't seem put off by the blaring music in the background. And those finishing their nights don't seem to be put off by the seemingly battery-powered yellows and greens and reds on the walls and tables. Then again, there's always the terrasse. This has got to be the only poutine palace with its own funky terrasse. And it must also be the only poutine palace with bagels on its menu.

But it's not for the bagels that they come to La Banquise. They come for—count 'em—twenty-two different varieties of poutine, ranging in price from $4.95 for a small Classic to $11.90 for Jean-Luc's choice, the large T-Rex. The addition of Italian sausage or pepper sauce

will set you back another $1.25.

Marie-Pierre Latendresse manages the six a.m. to four p.m. shift. Poutine is in her blood. Her dad has a poutinerie in the Laurentian community of St. Donat. Her brother Marc Latendresse and his wife Annie Barsalou are the current proprietors of La Banquise, which was in fact founded by Barsalou's dad.

Nothing surprises manager Latendresse. A group of ten wayward revellers has just drifted in. "It's interesting to see how everyone blends in," she says. "They are not in the same mental frame as other customers who are beginning their days. But poutine brings them together." I do believe there might be a song there. Poutine as the great common denominator. Although, at 7:12 in the morning, few hearty souls would dare begin or end their day with the Kamikaze, a blend of merguez sausage, hot peppers and a few dollops of Tabasco on the frites. This one could blow holes in the belly. Regardless, one of the wayward revellers has selected it.

"There are so many other places for poutine," Latendresse says. "But we have the ambience and we're always open. And, of course, it helps when you're the best in the city. Anyone who doesn't believe me should come when the bars close and see the mobs outside. It's like people are crazy for the stuff. They say it soaks up the alcohol in the system, but I'm no scientist."

Saying that La Banquise has the best poutine in Montreal means, many would argue, that it has the best poutine in the world. This is the same reasoning followed by the Schwartz smoked meat and the Fairmount/St. Viateur bagel braintrusts in declaring the global supremacy of their respective products.

Latendresse, thirty-two and the mother of two, is in fine shape, despite knocking back a poutine daily. Her fave is the Matty, a meal in itself, made of bacon, peppers, mushrooms and sautéed onions over the other stuff. More variations on the theme might be added to the poutine menu, but Latendresse is fairly certain there are no plans for a foie-gras combo. Too upscale and too costly. Doubtless chef Picard will be pleased to hear it.

Daniel Cerda has been the daytime poutine chef at La Banquise for the last two years. He is accustomed to hearing the praises of his

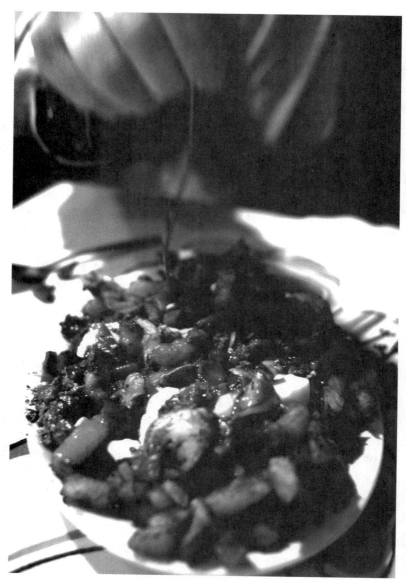

Mmm ... poutine for breakfast!

poutine from his customers, but has no illusions about being another Martin Picard just yet. "The real secret is that we use different potatoes from most others—ours are of the red variety. And we never over-fry the potatoes. Also, the cheese is special and always fresh. I can't overemphasize the importance of our cheese. As for the gravy, I believe ours is unique." Like the Colonel of KFC fame, Cerda won't divulge the recipe.

What he can divulge is that he immigrated here from Mexico seven years ago and had never heard of poutine before he arrived. "The first time I did hear of it here I have to admit I was puzzled," he concedes. "It's not exactly an obvious food creation, but people obviously go crazy for it."

Cerda can't take credit for the Mexican poutine—hot peppers, tomatoes and black olives over the usual—on La Banquise's menu. In fact, he admits it's not even his favourite. "To me, nothing beats the Elvis poutine," says Cerda, who is married to a Montrealer. "Sure, I like the name, but there's something about the way the ingredients (featuring hamburger steak, peppers and sautéed mushrooms) come together on a plate. I could eat it every day. Actually, I usually do."

To that end, Cerda lovingly prepares an Elvis poutine. "I find the colours pleasing, too," he notes. "I've got to say that I prefer poutine to tacos now."

He also admits he now prefers living here, too. "Winters are tough, of course, but the reason I chose to move here was that Montreal was the most European of cities in North America. It was easy for me to adapt to the language and the people. And, frankly, to the poutine, too. When I try to explain to friends and family in Mexico what it is that I do, they say they are happy for me but I think they are very confused. What we take for granted here, others do find puzzling. Montreal is, after all, a very unique place."

The Elvis poutine is prepared. "From what I've heard, Elvis would probably have loved this," Cerda says. "It's his kind of food."

No doubt. And all that's missing now is for Elvis to enter the Banquise building.

[La Banquise, 994 Rachel Street E.]

8:00 a.m.

THE MAN THEY CALL THE LORD of the Potatoes is sneaking a smoke outside his all-day breakfast eatery in Notre Dame de Grâce. Cosmo may be a city institution, but that doesn't mean its founder, Tony Koulakis, can puff with impunity. It used to be Tony's wife Erene who was on his case. But since she passed away a few years ago, it's their daughter Niki, now the mainstay at the Cosmo griddle, who's on his case.

"I see you. I smell the smoke. You can't hide from me," hollers Niki, in the midst of frying eggs and flipping bacon.

Koulakis promises this will be his last butt of the day. But not even he believes that. It's 8:14 a.m. Business, as always, is booming. Tables are at a premium. That's because there are no tables, just eleven spaces along the Arborite counter. Cosmo is a throwback to another era—one that precedes even its founding in 1969. Cosmo is your basic down-home, no-frills, no-ferns eatery that's geared entirely to your gut. Ferns would have no chance here anyway. Nor does your gut.

There may be folks obsessed with their diets, but they're not at Cosmo. Here we have cops and crooks, bank presidents and mailmen, chowing down on Cosmo's Mish-Mash Omelet, a 1,900-calorie combo of bacon, ham, sausages, salami, onions, tomatoes and eight eggs, served with a heaping side of Tony's famed hash browns. No accident that the Lord of the Potatoes has also been dubbed Captain Cholesterol and is the subject of a documentary titled *Man of Grease* and its anticipated sequel, *The Holy Grill*.

At Cosmo there is no room for clients with airs. Truth is, there is precious little air circulating around the griddle presided over by Tony and Niki, along with Tony's other offspring, Nikos and Johnny. The place is open daily from seven a.m. to five p.m., because people seem to crave breakfast at all hours. That is, people who like old-fashioned

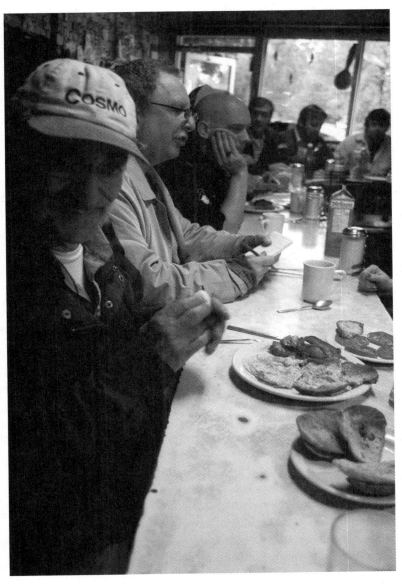

The Lord of the Potatoes—Tony Koulakis.

breakfasts devoid of fruit and yogurt and cottage cheese and exotic juices. Those types go to the plethora of trendy breakfast restos. Cosmo is no one's notion of trendy.

Peter MacLeod has been a Cosmo regular for twenty years. He is an organic commodities trader. And, yes, he gets the irony. But he can't live without Cosmo's bacon and eggs. He's pretty high on the Cosmo cheeseburger, too. "Homely, pretty homely," MacLeod says by way of describing the Cosmo decor. "But that suits me just fine. And where are you going to find a customer base like this? People from every walk of life imaginable, with nothing in common except an addiction for Cosmo."

Andrew Ramsey is another twenty-year vet. He looks fit. He seems bright, if only because he's playing Sudoku on a minicomputer. He is a database engineer, which confirms the original bright diagnosis. He comes to Cosmo every day for breakfast. He alternates between the French toast and the bacon and eggs. "I love the food, but I also love the people," he says.

Sous-chef Rosaleen Labelle chimes in: "We have to be careful, because he likes his bacon very crispy and his French toast soggy."

Mark Lazar had to be careful, too. He has been Captain Cholesterol's landlord for the last decade. The building's previous owner would only agree to sell if Lazar promised never to terminate the Cosmo lease. Lazar had no such intentions. "How could I ever have dared to close this place down? I would have had half the city after my head," Lazar says. And fumes notwithstanding, who could ask for a better tenant? "I used to eat breakfast here every day, but my rabbi told me I had to cut down on my bacon," Lazar cracks.

Time for Tony's breakfast: four eggs—over easy—plus a half dozen rashers of bacon—crisp—and a dozen heels of bread—toasted. "Tony will only eat the ends of the loaf that we would never sell the customers," Niki says.

Cosmo goes through thirty loaves of rye, kimmel, challah and black Russian bread a day. More than twenty dozen eggs and twenty-five pounds of bacon are fried every day, too.

Tony pretty much inhales his breakfast, before slipping out the door to light up again. "I see you," Niki screams. "I'm going to bring my

water pistol into work tomorrow and spray your cigarette every time you try to smoke. This time, I'm serious."

Tony, still puffing outside, concedes Niki is right. But he admits he's been in a funk since his Erene passed away. They were together all the time. Even when she was peeling the 150 pounds of potatoes a day for Cosmo, Tony would be by her side.

The plan had been for Tony to retire and to pass down the spatula to their grown offspring. Tony needed a break from his gruelling seventy-five-hour weeks. His doctors had been concerned about his back and blood pressure, not to mention his smoking. Tony had taken but one vacation through the years. He and Erene had dreamed of visiting their native Greece.

Then his world caved in. Erene was only fifty-nine. She had never been sick a day in her life. She didn't smoke or drink. But during a checkup, doctors diagnosed cancer of the pancreas. She died three weeks later.

"I still miss her so much. She was my whole world," says a sombre Tony. With her passing, retirement plans went on hold. Tony couldn't face the prospect of spending his days alone at home. Nor could his ever-faithful customers face the prospect of not bantering with Tony on a daily basis.

Tony was born on the Greek island of Crete and moved to Montreal in 1954 at the age of eighteen. "I had no money. I didn't even have a recipe for hash browns." That was about to change. The recipe for hash browns came when he married Erene in 1957. And the money was to come soon after Cosmo fired up its griddle.

Helping to ease Tony's angst since Erene's death has been John Jordan. He helps Tony with the peeling and the heavy lifting. He fries his share of bacon and potatoes. Plus, he cleans up and handles the cash register and pays the suppliers and does the books. He's essentially Tony's executive assistant and sounding board and, yes, cigarette buddy. But talk about an odd couple. Not only is Jordan about twenty-five years younger, he comes from a music, not a Mish-Mash omelet, background. Then again, in parts of Montreal, Jordan is as renowned as Tony. He was the front-man for the hit indie band Me Mom & Morgentaler, which disbanded in 1995 after a seven-year run.

"Our plans for global domination became futile, so the band fissioned," Jordan says. The group did get back together recently for a few reunion concerts, to the delight of its fans. They also released a new disc, *Shiva Space Machine: Gone Fission: Expanded Edition*, in late 2007.

"Tony and I have a lot more in common than people realize," says Jordan, who has been a Cosmo regular since he was seven—when the place first opened. "We both had to learn to perform in front of audiences. And Tony has played in front of just about everyone, it seems. Cosmo is like this city's Times Square. Everybody who's anybody—along with those who aren't—passes through Cosmo eventually."

Jordan still subsists on the fare, but, amazingly, has lost forty-five pounds in the year since he started to work here. "I've osmosed the food," he explains. "Osmosis is the name of the new superhero character I invented. He is a crime-fighter helping to battle mental illness and to get musicians to perform to benefit Ami Québec, a support group for mental illness. Although I'm better now, I had been hospitalized several times as a result of my bipolar disorder. That's why being with Tony has been such a blessing. He's like the dad I never had."

"And John is my best friend," Tony shoots back.

"Why we have adapted so well to life here is that Montreal is really a small town masquerading as a big city," Jordan says. "Everyone here is only two degrees of separation away from each other."

Tony nods. "People are surprised, but I really like John's music," he says. "It's beautiful even if it's quite different from the traditional Greek music I grew up with."

Niki doesn't know what to make of this mutual admiration society. But Tony concedes that Niki is the hardest working of his kids, and makes the best bacon. "My secret?" Niki says. "One slice at a time. Like life, really."

She's now at work on a Creation. The sandwich, that is—and not to be confused with the Lebanese version at Boustan restaurant. A Cosmo favourite, with only slightly fewer calories than the Mish-Mash, the Creation is a sandwich composed of fried eggs, bacon, salami, cheese, lettuce and tomato. "It's for those who have time to eat only one meal a day," Niki says.

By "those," Niki means guys. Because it's immediately obvious

that men make up nearly 100 per cent of Cosmo's clientele.

"That's why I'm secretly working on a women's menu here," she confesses. "Carrot muffins. Blueberry muffins. Banana bread. Yogurt. And, yes, fresh fruit, too."

Tony grimaces. Niki continues: "No cholesterol. No fat." Tony counters: "No cholesterol. No fat. No customers!"

Niki shakes her head. Tony smiles. "Really, I love women, but men are so much easier to serve," he says. "Men never complain about the food. Or about their diets."

Mailman Pierre Rosconi, another Cosmo regular, is about to dig into his Mish-Mash. When told it weighs in at nearly 2,000 calories, he laughs it off. "That's not enough," he says. "I need all the calories. I need all the energy I can get. My route is about ten kilometres."

Rosconi seems fairly fit. "I've been coming here since I was six years-old thirty-five years ago. We lived in St. Laurent, but my father believed in a good breakfast and I believe he was right."

Jean-Pierre Desjardins, Rosconi's pal at the post office, is a first-time Cosmo visitor. He stares in awe at his Mish-Mash. "I've never seen so much food on one plate," he marvels. "I'm just worried that I won't be able to finish it all. I don't want to be embarrassed here. One thing is certain, though: I won't be eating for quite a while after this."

"That's why I always tell my customers they must exercise if they plan on eating like this every day," says house-mom Niki.

Howard Steinberg, yet another regular who has been coming to Cosmo since it opened, loves the place because it is a throwback to the era he loved most. Steinberg may be one of the city's foremost experts on streetcars. Though he was only five at the time, it is with a heavy heart that he talks about the last regular run of Montreal streetcars: "August 30, 1959." His fondest memory is of the day that year when a conductor let him briefly take the wheel of a streetcar.

"Those were the days. The motormen would sing Christmas carols," he recalls. "Of course, they could also be sadistic. Sometimes women's high-heeled shoes would get stuck between the boards, and the motormen would slam on the brakes, causing them to fall."

Steinberg used to play hooky from school to scour the streetcar scrapyards for parts. At first he'd bring them home, but his mother

would throw them away. "So I had to take the parts with me to school. My teachers would be incredulous that a kid would come to school with a streetcar wheel or brake.

"In the days of the streetcars, there were diners like Cosmo on every corner," Steinberg says. "Now there are hardly any at all. There's Moe's on the corner of Closse and de Maisonneuve, and Cosmo, and not very many others. My big fear is that Cosmo will go the way of the streetcar—that people concerned about their diets will bring about the demise of this kind of place."

"Don't worry," Tony tells him. "The fancy diets have come and gone since I started here. But we have survived. One thing I've learned in life is that most people can't live without their potatoes."

The philosophy might not be up there with that of his fellow countryman Plato, but the Lord of the Potatoes may not be that far wrong.

[Cosmo, 5843 Sherbrooke Street W.]

9:00 a.m.

IT'S 9:21 AND L'EXPRESS is bustling with activity. That's 9:21 in the morning. To most people—Montrealers and tourists alike—L'Express almost perfectly embodies Montreal's status as the Paris of North America, bistro division. Small wonder. The place serves up some of the city's best comfort food and offers one of its most versatile wine lists, with surprisingly affordable prices. The decor is decidedly upscale minimalist. The servers, in their Parisian-style waiter garb, are decidedly professional. And the place stays open until the wee hours.

But what most people—Montrealers and tourists alike—don't know is that L'Express also offers one of the best breakfast deals in town. Not long after the last tippler has left the bar, L'Express reopens with a fresh-faced coterie of equally professional servers in appropriate garb. Except that much of the day staff is female, as opposed to the male-only wait staff at night. On the breakfast menu is the usual array of bacon and eggs, but, as a bonus, there is also a variety of cheeses and pastries. The espressos and cafés au lait are exquisite, but for adventurous breakfast-eaters seeking something a little more high-octane, a range of champagnes is also available.

The morning clientele is different from that of the evenings. There are few tourists on hand. Instead, the place is packed with the sort of life forms one would expect to see here in the city's Latin Quarter: bohos, journos, artistes, actors and barstool philosophers, chattering about political and cultural events of the day over a few espressos. It is not uncommon to find ever-piquant *La Presse* political cartoonist Serge Chapleau doodling in the corner. Or actor/comic/director Patrick Huard holding court in another corner. Or Rad-Can broadcasters mixing it up in a scrum.

On this morning, super-vedette Anne-Marie Cadieux, star of stage, screen and tube and a favourite thespian of uber-playwright Robert

Lepage, has dropped by for a little java, a shmooze and a photo shoot for Ici. Taking it all in from the next table is another of the city's fascinating, albeit eccentric, characters: Simon Finn, a musical refugee from London who has made his home in Montreal's Plateau Mont-Royal district for the last thirty-five years. Die-hard romantic that he is, Finn has a special attachment to L'Express. Several decades back, he would escort his ladyfriend of the time, a prominent Québécois actress, here for munchies and some tender bon-mots.

Finn likes to escape his digs. For good reason: having previously visited the place, I can attest that the interior of Finn's Esplanade St. flat often looks like it's been struck by a small bomb. But what could pass for after-blast debris is actually clothing, dishes, empty bottles, boxes, stereo components, instruments, discs and, oh, can't forget those Finnish water filters—or parts thereof—strewn randomly about his second-floor walk-up.

Finn, a glass-half-full kind of fellow, feels that "artistic clutter" is a more apt description of the chaos. He has accumulated thirty-five years worth of artistic clutter. It was back in 1972 that the Surrey-born singer-songwriter left London to move to Montreal for no good reason other than a quest for a new adventure. But shortly after arriving here, he was smitten, and the love of that woman led to his settling here for good—although they have since parted company.

Not that Finn's musical career was exactly on fire in England back then, but his first disc, *Pass the Distance*, had been released in 1970 and he was regularly playing the legendary Marquee Club in Soho, even opening for the likes of singer-songwriter Al Stewart. "I might have been making about a quid a night then, but Al was really making it, earning perhaps as much as two quid a night," Finn deadpans.

Finn has no illusions about his place in the pop pantheon. Never has. If pressed, he might label himself a "psychedelic folk musician." And if that conjures up something dark and twisted, so be it. Mellifluous and melodious would probably not be the adjectives that pop to mind in describing, respectively, Finn's voice and musical stylings. However, if it's haunting lyrics and heartfelt expression you seek, Finn is your man.

He launched his latest disc, *Accidental Life*, at Casa del Popolo in

Simon Finn at L'Express.

the fall of 2007. A Finn record launch is an occasion. He's had two in the last thirty-seven years. He did cut another disc, *Magic Moments*, in 2006, but it was more of a homemade production, had no royal send-off and wasn't widely distributed.

Nevertheless, the wheels are beginning to turn a little faster for Finn. He doesn't have an agent, manager or promo person. And far be it from him to toot his own horn. But he does have friends, and they go to great length—all pro bono—to see he gets his due. Now, that's love.

Almost like the love that first kept him here. "I gave up my music for marriage and organic farming," reflects the fit Finn, who is fifty-seven but could easily pass for ten years younger. "It seemed like a good idea at the time."

In retrospect, not such a great idea. Organic farming wasn't exactly in vogue here thirty-four years ago. And the marriage? Well, it didn't last long. So Finn, the absent-minded intellectual, took to teaching—karate, of all things—to make a living. "Funny, but the only reason I know karate is that I took it in school to get out of doing rugby."

Alas, the market for teaching karate wasn't real big back then, either. So Finn next ended up investing whatever fortune he had left in Finnish water filters. "You would have thought that I could have at least sold some of these to my fucking friends, but nooo," he says, shaking his long brown locks back from his face. "And wouldn't you know that today all these buggers have those bloody Brita water filters. The bastards!"

The fates didn't smile on Finn's timing. "Everything I got into back then has since mushroomed. Organic farming, karate, and bloody water filters!"

So the fates pushed him back to his first love, music. Hence the title of his new disc, *Accidental Life*. It was released in England in early 2007— "but I haven't the faintest idea how it's doing."

Finn has a way with song titles, like "Rich Girl with No Trousers." The mistake would be to conclude this is an erotic composition. For most other artists, perhaps it would be. But not for Finn. It's actually a very moving ballad in memory of a friend who succumbed to Alzheimer's disease. "I have an infinite respect for writers who can write light yet profound. But I can't do it."

Fifteen of the sixteen songs on *Accidental Life* were composed by him. The sixteenth was written in 1806 by Ann and Jane Taylor: "Twinkle Twinkle Little Star." Yup, that one. "The words are really quite lovely and the beauty of it is I can duplicate it on stage with one guitar," Finn states.

And, go figure, Finn does succeed in bringing a poignancy to this tune no one could ever have anticipated. As he notes, he has actually moved people to tears, for the right reasons, with his rendering of "Twinkle Twinkle."

But Finn is a realist. He doesn't expect folks to twig to his latest disc right off the bat. Why would he, given the track record of the first one, *Pass the Distance*. It was only when he learned a few years ago to Google himself that he discovered *Pass the Distance*, which came out in 1970, had become a cult classic and that fans were bemoaning the fact it was unavailable.

"I'd avoided Googling before, because I assumed it was a bizarre sexual practice. But there I found the most favourable reviews. I was flabbergasted."

So a producer remastered and reissued the disc, and, poof, a career was reborn. Said producer wanted to record more Finn. "Being the horrible, self-sabotaging fuck that I am, I sent an endlessly long dirge called "Eros," about the perversity of Cupid. I figured that would be the end of it. But no. He quite liked it. So I had to learn how to sing and play again, because he wanted me to go on the road. But it's been fun. I get to meet lovely mad people and get to travel the world."

And what about subsistence? "Yes, I even get a stipend. Astonishingly, I'm surviving."

Finn did a 2007 tour of the U.K. and the former U.S.S.R—and he does indeed know "just how lucky I are." He plays clubs and concert halls and, to his amazement, they sell out in such picky cities as New York, San Francisco and Chicago. Still, his heart remains in Montreal.

"When I first arrived in Montreal in February all those years ago, I thought my fucking ears would snap off like biscuits. But I've learned to adapt. And I've learned to accept my music being downloaded now for $2.19."

To his amazement, Finn is no longer the anonymous figure he was

in Montreal. Media exposure has brought him to the attention of folks who had seen him around the 'hood for years but had no clue who he was. "I've been going to this gym for years, and this guy who has also been there for years just came up to me, after seeing my photo in the newspaper. He said he could be my bodyguard if I wanted," Finn says with a big smile. "I had to tell him, though, that it's not humans I'm scared of at this point in my life. It's just about everything else."

Fact is, though, that Finn, with his black belt in karate, can more than take care of himself. "Funny thing. though, I've only ever had two physical confrontations in my life. And only once did I have to pacify someone. That was defending a dog at the wedding of a friend."

It seems a wedding guest was pummeling a dog that was having an altercation with another dog. Finn tried to get the guy to lay off, but to no avail. So he simply had to flip the fellow over a sofa. The altercation with the human ended quickly. "Mostly, karate has helped me keep the demons out of my own mind," he notes.

Finn admits to pondering his existence more than ever of late. "I've decided that I'd like to die like an octopus. It would be a quick, painless death and I could provide people a good meal in the process."

Finn is not like other people. But he does fit in well in Montreal. When asked for his breakfast order, he surprises the waitress by asking for his eggs in "le miroir" fashion. That would be sunnyside up. "I decided the best way to adapt to the city would be to get involved with French women. ... This is one of the last great romantic cities of the world. The way London was in the 1960s and New York in the 1970s. I love places like this where you have the oddest collection of characters, from artists to philosophers to bricklayers, from deadbeat journalists to used-up musicians like me. What makes it so special is the way everyone interacts so effortlessly, be it by talking politics, playing pool or just meeting women."

A fellow at a nearby table has been listening in on Finn's conversation. He asks what kind of music Finn plays. "Mostly, I whine about my personal life, and if I'm lucky, I get a few other musicians on board with me."

The fellow seems to comprehend, but then comments that Montreal is perhaps not the best base of operations for an English

singer. "Pragmatics would suggest I live elsewhere, like London, but it's romantics—actually, romance—that keep me rooted in Montreal," Finn responds. "And what I love most about the city is its great acceptance of eccentrics. People here don't often judge others by the way they look or act. They could be hopping on one leg with a balloon in hand, and they could be running the World Bank. If people did judge others by the way they looked or acted, it would be tough for the likes of me, especially if you're trying to meet women and you look like you have no money—and, worse, you don't. Then you'd have to fall back on character—and that wouldn't be easy, either."

All the same, Finn points out that the city has changed since he first settled here. "Rents and house prices have risen dramatically. It used to be one of the great cities to live in on a budget."

Finn pauses to ask the waitress for some typically British marmalade to put on his French bistro baguette. The condiment sets him off on another tale. "When I first arrived in Montreal, there was a Marks & Spencer store here. The food part was doing well, but the fashion part wasn't. So I called Marks & Spencer's head office in London and suggested they forgo the fashion and focus only on food. I never heard from them again. But, sure enough, Marks and Spencer have since set up small, food-only outlets."

And, once again, Finn was ahead of the times and missed another opportunity for major cash. "Oh well, that's life—for me. No big deal. I move on," he shrugs, before finishing chomping on his marmalade-smothered baguette.

On the bright side, he also recently learned that not long ago a newspaper in Toronto picked a Finn concert as the best one to catch, over shows by Bob Dylan, the Foo Fighters, Steve Wynn and Alice in Chains. "I was absolutely stunned," he says. "Almost as stunned as to learn that as a result of my recent success with my music, the Quebec Pension Plan has informed me I that could collect five dollars a month now, or wait till I'm sixty-five and get seven dollars a month. I'm so tortured with indecision. Really, does it get any better?"

[L'Express, 3927 St. Denis]

10:00 a.m.

THERE'S NO DENYING that java joints have been sprouting up, almost uncontrollably, all around town. There's hardly a corner of the downtown core that doesn't house a Second Cup and/or Starbucks. Not too many decades back, most Montrealers had to content them-selves with your basic burn-your-gut chuckwagon blend of coffee. No longer. Dynamite taste requires dynamite java, and Montreal may now rival Seattle for caffeine addiction. We have become a city of caffeine sophisticates. We know the difference between mochaccinos, macchiatos, cappuccinos, granitas, espresso Americanos and con pannas. Even though the latter are mostly milk drinks with a drop of java, swill enough of them in a day and you'll still have to be scraped from the ceiling.

There are theories out there explaining the proliferation of the coffee house. Best of the bunch is that coffee houses are the new singles bars for the new millennium, and latte might well be the most potent love drug around—provided your intestines can withstand the onslaught of lactose.

Vito Azzue doesn't disagree. He operates what many Mile End residents consider to be the best down-home java joint in town, at the corner of Waverly and St. Viateur Streets. It is no one's idea of trendoid, and Azzue eschews the fancy-pants brews, serving only espressos, macchiatos, cappuccinos and caffe lattes. Yet the place is so popular that he never had to fix the old sign above the door. Indeed, the fact that some letters were missing from what was written there gave rise to an idiosyncratic moniker that insiders still consider more fitting for this veritable city icon. Its real name may be Café Olimpico, but dyed-in-the-wool Mile Enders rarely call it anything but Open Da Night.

The café was around before the java chains came to town and it will be around after they leave. For nearly forty years, it has been "open day and night," dispensing espressos et al, first to Italian and other Euro

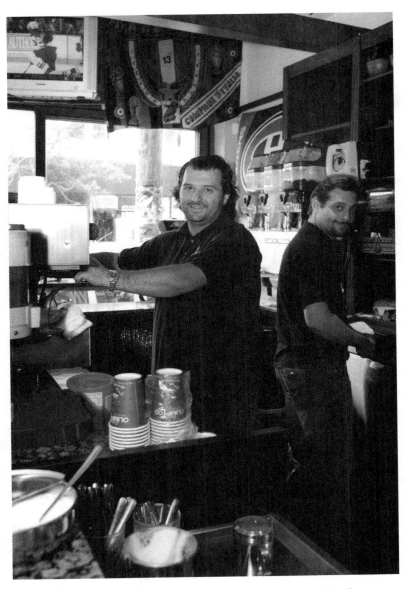

The Love Café baristas Vito Azzue (left) and Vince Spinale.

immigrants in the 'hood, then to the artists and students who have since flocked to the area, and now to just about anyone in town with a nose for the best beans around.

Azzue notes that business has really boomed in the last decade with a new breed of customer. "There's no question that the latte has really helped," he says. "Let's face it: there's a limit to how many espressos someone can drink in one sitting. It's a social thing now. Some customers are calling us the Love Café—because they say this is a great pick-up spot. And, of course, it helps that coffee is still a lot cheaper than booze."

Open Da Night's coffee, that is. Prices here range from $1.75 for an espresso to $2.25 for a cappuccino. Some of the chains, on the other hand, charge as much for their concoctions as for an alcohol-laced cocktail. "Starbucks is more but they do offer free wireless and invite people to sleep on their sofas," Azzue cracks. "We have no sofas here. We do have a bench and a pool table, but so far no one has tried to sleep on the pool table."

It's 10:23 and this pick-up spot is buzzing. The lineup at the counter stretches almost out the front door. Customers—of all ages, sexes, linguistic and cultural backgrounds and professions—wait patiently in line to give their orders to Azzue and co-manager Vince Spinale behind the nozzles. It takes this master barista tandem less than twenty seconds on average to prepare most orders. The more latte involved, though, the more time-consuming it can be. A caffe latte can take as long as thirty seconds. But unlike the Soup Nazi of Seinfeld fame, Azzue and Spinale never lose it with undecided or slow-to-speak clients. The duo are charmers. They even manage to make small talk with customers while steaming latte. They also know what most regulars will order even before the words come out of their mouths.

"We're originals," Azzue claims. "We do our work with heart. And our coffee is consistent. Consistently good. It's like an exact science for us. We know we have to duplicate what we've done before."

To that end, Azzue and Spinale use thirteen different kinds of espresso beans to arrive at their special blend. Unlike most other java joints in town, Open Da Night sells only coffee and desserts, specifically biscotti.

"The pressure, though, is always on," Azzue notes. He's not talking espresso-machine pressure, either. "I have my good days and my bad days behind the counter. Sometimes I'm too fast on the foaming. Sometimes I'm too slow. Perfection ain't easy."

The best days, without question, are the more balmy ones when the terrasse is open. The best days indoors are World Cup soccer days, when fans of Forza Italia follow with rapt attention their team's exploits on one of the several wall-mounted TVs. "But I must say we are very tolerant of those who come in rooting for other teams, even France," Azzue says.

He has been behind the counter since 1995, when he was all of twenty. Spinale came three years later, when he was also twenty. The two are childhood friends, having grown up three houses away from one another in Mile End, a couple of hundred metres from Open Da Night. "We're like bloodbrothers," Azzue says. "If we were real brothers, it wouldn't work. We'd be at each other's throat."

But coffee has been very good to the boys. They both have spacious homes in St. Léonard, where they live with their respective wives and children. But Azzue leads Spinale in the kiddie count, 5 to 1. "I guess I've got my work cut out for me," cracks Spinale, in reference to the breeding.

Open Da Night is so mobbed at times that Azzue and Spinale aren't aware that a slew of city celebs, from pop to sports stars, are sippin' their espressos in the corner. "One day, a customer pointed out this couple to me and told me they were the lead couple from Arcade Fire," Azzue recalls. "I said: 'whatever.' They've been coming here for years. They're just down-to-Earth regular folk who wait patiently in line like everyone else."

Corrine Leon, noted publicist around town, is also content waiting in line for the best espresso around. "It's the coffee but it's also the vibe here that really helps. It's just so relaxed and friendly. Like the city itself," says the statuesque Leon, who lives a few doors away and handles P.R. for the Just for Laughs comedy festival, the R.I.D.M documentary-film fest, as well as CBC-TV.

"That's what impresses me, too," Azzue chimes in. "Someone could be sitting alone at a table, and someone else, a stranger, will join them

and start chatting. I know of many cases where people have met their future spouses here. Remember what people say about the café being the singles bar for this century." Leon doesn't doubt that. She didn't meet her mate here, but they do come by together regularly, drawn by the sweet smell of coffee. "This sort of café doesn't exist in Toronto," she says. And she should know. Leon left her hometown of T.O. in 1996 to study at McGill University. She never left Montreal. She fell in love with the city and Mile End in particular. "I also really fell in love with the people and the pace of life here. In Montreal, people work to live. In Toronto, they live to work," says Leon, echoing the sentiments of many others, both in Montreal and Hogtown. "I just take enough contracts to live. I have no savings, no RRSPs, no benefits, no trust funds. I live in the moment, and I love it.

"Of course, my friends from Toronto think I've gone off the deep end. What about quality of life, I ask them. What about it, they say. At least my mother realized a long time ago that I was different and had a mind of my own."

Azzue returns to the counter. Spinale comes to join us at the table. "I love when I hear stories about people moving from Toronto to Montreal," he says. "For too many years, the traffic was going all the other way. Not to put Toronto down or anything. I was there for the first time not long ago. It wasn't such a bad place to spend a weekend. But I couldn't ever live there."

Spinale is impressed that Leon immersed herself in the city's cultural life and has become totally bilingual—which is more than can be said about many of this city's native anglos. "I studied French in Toronto and learned to conjugate verbs eight different ways, but I never really spoke French until moving here." Now she not only speaks the language but also writes press releases in it.

"When I arrived in Montreal, it was not long after the referendum here," she adds. "People in Toronto thought I was really nuts to come here. My high-school guidance counsellor told me McGill was a good school, but that Montreal was way too politically unstable. I paid no heed and moved here anyway. And I have never regretted it once. And I've never really been put off by any political instability."

Spinale interjects: "That's the perception people who don't live

here have of Montreal. But I can honestly say politics has not affected our business. People don't come here and talk politics very often. They care more about our biscotti than Lucien Bouchard," he muses.

Spinale favours the lemon biscotti over the popular chocolate biscotti. "Customers seem to prefer the lemon for dunking, too," says Spinale. "But, honestly, I have a confession. I'm not much of a dunker myself. I drink espressos and the cup is just too small for dunking."

Thanks for sharing, Vince.

Spinale is pleased to report that there have been no java brawls in the place over the years, even though the consumption of much caffeine can make folks easily addled. Which brings up the issue of just how many coffees are served in the course of a day here. Some say more than a thousand. Azzue and Spinale have a different number: "A couple of dozen, maybe," says a winking Spinale. Azzue, within earshot behind the counter, seems to concur.

Their numbers may be off a tad, but there's no denying there's money to be made from the coffee bean. Do the math. The decor has been largely the same the last forty years—basically, down-home poolroom. Even though there was a fire in 2004 that forced them to close shop for four months of repair and renovation, Open Da Night reopened looking pretty much the same, which is to say it was still not a candidate for a spread in *Architectural Digest*.

Spinale is also pleased to report that he rarely has spats with partner Azzue. "People say we're like an old married couple. We might have different ideas at times for the business, but we end up making up. We even hang out socially outside of here. We really never argue."

Okay, that's not entirely true. "I'm sad to say we do argue about hockey," Spinale remarks in a low voice. "I love the Habs. He hates the Habs. He is a bloody A.B.C.—Anybody But the Canadiens. It's for no reason at all. The Canadiens have never done anything to him. Vito just has to be different. What's that all about?"

So, Vito Azzue, what is that all about, anyways? "I'm proud to have been an anti-Hab all my life," he says. "I just don't know why, but I find they whine a lot. There is no whining in hockey. Or espresso."

Think I smell mantra here.

[Cafe Olimpico (Open Da Night), 124 St. Viateur Street W.]

11:00 a.m.

AMIR ESSAATI CHOMPS into his Special. His eyes light up. "What's cholesterol?" he jokes, while wiping crumbs and remnants of mustard from the corner of his mouth. Essaati may only be a Grade 11 student, but he knows darn well what cholesterol is. He knows what triggers it. He knows the consequences. The kid happens to be a brainiac.

Essaati is on a field trip with teachers and fellow students from Laurier Senior High School in Laval. English teacher Isa Tozzi figured it would be a capital idea during the study of Mordecai Richler's *The Apprenticeship of Duddy Kravitz* to bring her students to the Mile End area where it is set and specifically to Wilensky's restaurant, immortalized in the Richler opus.

Wisely, she has chosen to bring her group of a dozen students in before the stampede of the noon-hour rush. It's 11:34, and her students are blissfully chewing away on a sandwich they have never tasted before, in an eatery they have never visited before. "This is like a shrine," rhapsodizes Essaati. "This is one of those rare places that have played a unique role in Montreal's cultural history."

"This is just like the movie," marvels teacher Tozzi. "There is so much history here. It's overwhelming."

"It's simple, frugal, functional food," adds the erudite Essaati. "This is not for those looking for something ornate or fancy. This brings us back to the days of yore. It's an ephemeral connection with a simpler lifestyle born out of the harshness of the depression. It's like a pearl in the midst of a massive ocean. A real treasure in the heart of the city, and it's truly a mosaic of the city."

To which the moderately blasé Sharon Wilensky responds: "That's very nice, but from where we're standing on the other side of the counter, it's a lot like work to us."

"Amir was hit by a dictionary as a child. Forget the fancy words, it's

mmm, mmmm good," says a grinning Meaghan Henstridge, another student in the class. "I'm going to bring my parents back here."

"It's awesome," says a wide-eyed Alexander Melchiorre. "When you think about it, it's amazing that a place this small could survive this long with such a limited menu. What's the story?"

Its official name is actually Wilensky's Light Lunch, which has to go down in the annals of great oxymorons, in view of its highly addictive yet cholesterol-laden grilled salami/bologna Special served with a dab of mustard on an onion roll. As noted by keen student Essaati, Wilensky's is an ode to bygone times, when stripper Lili St. Cyr, blind pigs and barbotte were all the rage. It feels and looks much the way it did when Richler paid homage to the place in Duddy Kravitz.

A few months before our visit, there was joy—of sorts—and perhaps just a little gas at this Fairmount Ave. landmark. Stoic though they may be, the Wilensky family were handing out party hats and blowing up balloons. They were even serving champagne and cake and, natch, the Special. Maybe even a few egg-cream sodas, too. They weren't holding back. That's because Wilensky's was celebrating its 75th anniversary with a party for family, friends and longtime habitués of the eatery.

Considering that some restaurateurs get into giddy party mode after only ten years of existence, Wilensky's longevity is remarkable, all the more so because it has served essentially the same fare since it was founded by Moe Wilensky in 1932. Sure, the Shlafman family of the nearby Fairmount Bagel shop is set to mark its ninetieth birthday in the bagel-making biz, but even that brood of bakers has made concessions to the new millennium by adding new bagel creations to its repertoire.

However, to state that Wilensky's menu remains forever unchanged is "not entirely true," Asher Wilensky says. "We've made a couple of concessions, too. The original Special had no cheese. Now we add Swiss cheese for those who request it." All righty, then.

"A Classic has no cheese, but we aim to please," says Ruth Wilensky, forcing a smile.

As for another Wilensky's client-pleaser, the famous egg-cream soda, which can be found hardly anywhere on the planet outside New York City: "It's got no egg. It's got no cream," grunts Asher. "It's a mix of chocolate syrup, soda water and milk."

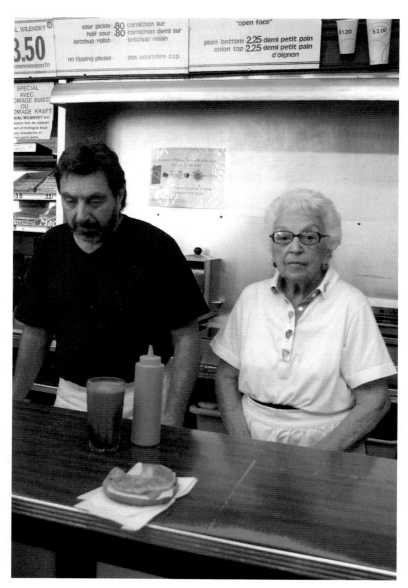

Asher and Ruth Wilensky keeping the tradition going—
one Special at a time.

"Think someone in our family went on a reconnaissance mission to Brooklyn to get that recipe," cracks Sharon.

Moe Wilensky first opened for business in another building on Fairmount, as a resto-cum-cigar-emporium-cum-barber-shop with Moe's dad, Harry, doing trims in the back room. In 1952, Moe moved to Wilensky's current location and ceased with the scissors and the stogies to focus solely on the Specials and the egg-cream sodas. Nothing here has changed since. Arborite and hospital-green paint rule. There is still room for only nine customers on the counter stools. There are no tables. There are no plates or silverware, either. You make do with a napkin and your fingers, or else you go to one of those chichi uptown places that offer cutlery with the grub. The hours haven't changed, either: Monday to Friday, nine a.m. to four p.m.

The faces behind the counter remain pretty much the same, too. There's family matriarch Ruth Wilensky, Moe's widow, still spry and barking out the orders at eighty-eight. There's son Asher, whose fitness suggests he hasn't been packing away an inordinate number of Specials over the years. And there's daughter Sharon, who professes to be a vegetarian but confesses to a bad karnatzel habit. Still being mourned is their younger brother Bernard, a fixture behind the counter until he passed away eight years ago. Rounding out the team are longtime countermen Scott Druzin and Paul Scheffer. "As long as they all do what I say, we get along just fine," says Ruth.

"Otherwise we get a smack in the mouth if we don't listen," claims Asher.

As regulars are abundantly aware, the Wilenskys ain't shmoozers. On occasion, they'll smile and say hey. But they have no time for small talk. If you want pleasantries, again, go to one of those chichi uptown places with cutlery. This is the drill: customers march in, place orders, are served within the minute, devour their Specials in minutes and are out of the place about ten minutes later.

And just in case you have a question about the menu or the service, the gang can point to this little poem over the counter: "When ordering a Special, you should know a thing or two: It is always served with mustard. It is never cut in two. Don't ask us why. Just understand that this is nothing new. This is the way that it's been done since 1932."

That suits the Wilensky's faithful just fine. There are still several customers who go back to opening day seventy-five years ago. Others are more recent converts. "I feel the love whenever I walk in," says newish devotee Urs Jakob, originally from Switzerland. He makes his living leading expeditions to such exotic spots as Mauritania and Tibet. "Wilensky's is about as authentic as anything I've ever seen in the world," says Jakob, accompanied as always by his ten-year-old son Cedric. "I just hope one day my son will bring his son here, and keep the tradition going, and that he too will feel the love."

Ruth, who is not easily flattered, just shrugs upon hearing how love trumps salami as the main attraction. "I always thought the key to success is to keep things going the way we always have," she says. "And that's keeping it simple."

Simple seems to work. Wilensky's caters to cops, politicos, CEOs, celebs, tourists and locals from all cultural fronts. This place plays no favourites. Those who have double-parked their Benzes outside wait for counter stools just like the blue collars who have made the trek on foot.

On average, customers pack away two Specials ($3.50 each) and complement the meal with a Cherry Coke, made from scratch, the old-fashioned soda fountain way. But Asher still recalls seeing one gent knock back—count 'em—ten Specials in one sitting. "Plus, he also took out another six," he marvels. "I felt great after making that order. I don't know how he felt after eating it all, though."

Accountant Don Chazan has been making the pilgrimage for nearly forty years. It's about the beef. "But it's also about how coming here transports me to another time and place," he says. "It's just enchanting."

Also on the menu since the beginning, Sharon Wilensky quickly points out, are cheese and chopped-egg sandwiches, for the more health-conscious.

"Great," accountant Howard Liebman, another Wilensky's lifer, shoots back. "Another clogger here, please!" He is, of course, referring to the Special.

Roger Velosa, a regular for the last ten years, makes an order for fifteen Specials to take out. "They're not all for me," he insists. "Unless I get stuck in traffic bringing them back to the guys at work. This is my

favourite sandwich in the city. I believe it's addictive."

Salami has been called many things, but a drug? Evidently so. Lorne and Olivia Rodin also suspect it might be. He's forty-one and has been a fixture at the Wilensky's counter for thirty-five of those years. Olivia, his daughter, is nine and has been chewing on the Special for the last three years. "She's a third-generation customer," Lorne says. "I think my father, who has passed away, was among the first here when the place opened. We come out of respect for him. But we love the Special, too. It hasn't changed in the thirty-five years I've been coming. It's all about the continuity."

Dentist George Hwang, a twenty-five-year Wilensky's man, won't comment on a buddy's statement that "four out of five dentists recommend the Special for their patients." Nor will he make a comment about the correlation between salami and the bone density of teeth. "What I will say is that it tastes terrific and that I love coming here because I don't even have to tell them what I want. A minute after sitting down, my usual Special and sours are in front of me. That's special! So is being served by Sharon."

"I just can't shake this place," says Sharon. "I started working here when I was twelve. Later I taught English as a second language. But by gravitational force or something, the place pulled me back and I've been behind the counter the last five years. So what if we have the occasional squabble with family members behind the counter? It's like we were destined to do this."

All tips collected at the counter go directly to the Montreal Heart and Stroke Foundation. But, please, no snide remarks how these funds might one day benefit Wilensky's customers. Ruth Wilensky doesn't take kindly to such talk, and you really, truly don't want to make Momma mad.

[Wilensky's, 34 Fairmount Street W.]

Noon

IT DOESN'T LOOK LIKE MUCH from the outside. Hell, it doesn't look like much from the inside. It's a bloody basement, in fact. Stucco ceilings and wooden beams from a past decade—nay, century. Ceiling low. Lighting barely adequate. Floor plan an afterthought.

Looks can be deceiving. More than forty years after its founding in 1966, Le Mas des Oliviers remains the city's power-lunch spot for politicos, barristers, brokers, bankers and boulevardiers. What the place may lack in architectural felicities, it more than compensates for in charm and ambience. The food is classic old-school French. The service is even more classic old-school French. Even if you've been there but once, maitre d' Quentin Blouin remembers not only your name but your favourite libation—and the garnishings that accompany it—and your favourite food—and how it's cooked—and your favourite wine— and the price you desire to pay for same. In a city where the food is universally fine but the service can fall short, Quentin Blouin is the quintessential maitre d'—and hence the engine that keeps Le Mas des Oliviers running so smoothly. Nouvelle cuisine joints, with their high-tech minimalism, come and go in this town, but customers continue to flock to Le Mas because they can count on consistency. And the fish soup and frites ain't too shabby, either.

It's 12:46 p.m. Every table is full, mostly with gentlemen of a certain age and social standing, wearing suits. The bar is where the hipster kids hang—and by hipster kids, we mean those under sixty-five not sporting suits. We make a beeline for the bar and grab the last empty spots. We order Bloody Marys. We knock back the complimentary olives and spicy chunks of sausage and even munch on a couple of healthy carrot sticks. Then we take a long look around to see who's who at Le Mas today. Providing play-by-play commentary is my buddy and colleague Hubie Bauch, veteran political writer with *The Gazette*.

He confirms the obvious. What used to be considered the official Conservative Party clubhouse—when Brian Mulroney was P.M.—is now full of folks who aren't trying to curry favour with politicos or to sell dubious get-rich-quick schemes. "Amazingly enough, the power-people are still here but they appear to come more for the food and the attentive service," comments Bauch. "Gone are the days, it seems, when journalists could uncover political scandals by eavesdropping on conversations at the next table."

One of the few familiar players on hand today is Brian Gallery, former mayor of Westmount, former head of CN, former Mulroney adviser, former Jean Charest adviser and former Paul Martin adviser, and a man who knows all the other players without benefit of a program. His scan of the restaurant comes up empty, too. "There is the usual contingent of big-shot lawyers, bankers and brokers, but if there is still a Conservative Party base in Montreal, it's not here," Gallery opines. "Like me, people actually come here now for the food and, of course, the service."

The reality is that the blue-blood Conservatives of yore have faded from the scene. There is a Conservative movement, but it's not in Montreal. It's in the boonies, according to Bauch and Gallery.

Frankly, the prospect of Le Pescadou et sa rouquine—a fish soup with accompaniments—turns Bauch on more than the chance of an encounter with a Tory bagman. "It's not just soup—it's a ceremony," Bauch says. The soup is served with roasted garlic cloves, shredded cheese, a Provençale-like sauce of tomato and mayo, and toasted slices of baguette, which constitute the aforementioned rouquine. A dip here. A rub there. A slurp of soup in between. And Bauch is in a state of bliss rarely associated with soup.

"There could be felons—indicted or otherwise—around me, but I wouldn't notice," he says, such is his rapture with the pescadou.

His main course is another Le Mas classic—the boudin. "Admittedly, it's hard to explain to those not in the know how divine something which is essentially a blood sausage can be. Really, we're talking clots of blood here." Yum. "But remember, it's also very rich in iron," adds Bauch.

"It's remarkable," he continues, glancing around the room. "This

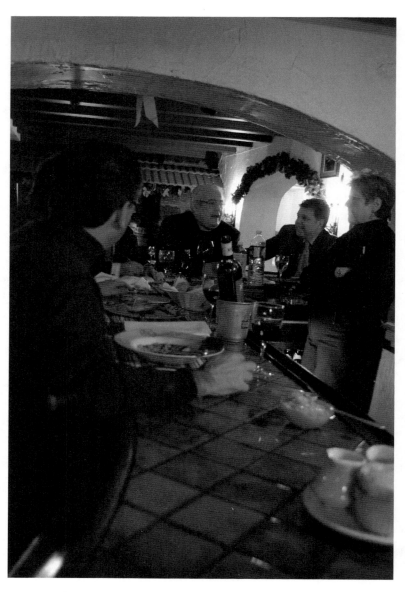

Le Mas's mother hen/bartender Elise Varo makes sure what is said in Le Mas stays in Le Mas.

place hasn't changed since the first time I visited in 1969. It looks exactly the same. Maybe they changed the espresso machine, but that's about it."

Gallery stops by with a few of his own observations: "In the old days anybody who was anybody in this town was here, and everyone knew it. There was a lot of history made here. Deals went down. But best of all it was Montreal all the way. You would never see tourists coming here at lunch. And you still don't. The place looks like a private club, with customers going from table to table to talk."

"It wasn't just an old-boys' club for Tories, but for political journalists, too," acknowledges Bauch. "We had a group of guys who would meet here. Luc Lavoie, Michel Vastel and others who had served in the National Press Gallery in Ottawa." Apparently, admittance to this august group of journos was based on "having been spotted drunk at least once on Wellington Street" near Parliament Hill.

And if the journalists or anyone else at the Le Mas bar did misbehave or tell tales out of school, they could count on the discretion of Le Mas's mother hen and bartender Elise Varo, who next to Blouin and founder Jacques Muller is viewed as the glue of the place. Varo has been slinging cocktails at Le Mas since 1979, but it's not her ability to mix a few ounces of vodka with tomato juice and spices that makes her such a valuable asset. It's her ability to keep what she knows to herself. "I have seen a lot. I have heard a lot. I say nothing. I will take secrets with me to the grave. I am discreet at all costs," she says, a twinkle in her eye.

On that note, don't be expecting Varo to spill the goods on a political brawl that may have taken place a decade back at her bar. You'll have to go elsewhere for gossip like that. The most political poop she will dish out is that the worst-ever customer she served was a well-known scoundrel who got his comeuppance in the Gomery Commission Report. (Let the guessing games begin!) She does allow, though, that Brian Mulroney was a regular, that the late Mordecai Richler—not a fan of the latter—had his own table, that former Habs great and hotelier Serge Savard can still charm as well as he could skate or stick-handle: "a real gentleman, generous and polite to a fault." That Jean Drapeau, Jean Chrétien, Pierre Trudeau, John Turner, Jean Charest, Lucien

Bouchard, the Johnson boys (Daniel and Pierre-Marc) and Bernard Landry have all broken baguette here. So, too, have Peter Ustinov and P.D. James and Martin Scorsese.

"People would always say this was a Conservative Party headquarters, but the reality is that we would have Liberals sitting next to Conservatives sitting next to Parti Québécois and Bloc Québécois members," Varo remarks. "We still do. And, imagine, even NDP people come."

When asked about her own political leanings, the ever-circumspect Varo covers many bases when she announces that she's "a federalist nationalist who believes separatism is passé."

Curiously, Varo actually paid her rent as an actress before moving over to the bar—for most thesps, the ideal career path is usually the reverse. She continues to make appearances in film and TV series, but she views her work behind the bar as the ultimate acting experience. "My life is Le Mas. The bar is my theatre. I'm performing all the time," explains the vivacious Varo, who married for the first time in 2005 to singer Guy Roger—Quebec's one-time Mr. Twist. "The beauty of this job is that every day is a different scenario. It's like improv for me."

All the more so since Le Mas is one of the few places in town where the three-hour, three-martini, three-bottle-of-wine lunch still continues—and even flourishes.

Taking in this conversation is the ubiquitous Quentin Blouin, the maitre d' with the most. "What I've learned is that nothing beats diplomacy and discretion," says the affable Blouin, maitre d' at Le Mas since 1990 and partner since 2004. Though born in Montreal, Blouin attributes his skills to his parents from France, who taught him the basics of cuisine and service.

"The key to success here is loyalty and consistency," he points out. "And, of course, discretion. We accept all political parties. We play no favourites. At the same sitting, we can have Brian Mulroney, Bernard Landry and Jean Lapierre all placed next to one another, and there will be no fighting whatsoever. Politicians and our other regulars come here because it's like a second home to them. They just feel comfortable here."

The fit Blouin took a circuitous route into the restaurant trade. He

graduated from university with a commerce degree and later went to work in the IBM marketing department. "Then I did the unthinkable. I left the predictable world of commerce for the unpredictable world of restaurants," he cracks. "I always felt more at ease dealing with people than being behind a desk."

Blouin earned his stripes toiling at such city institutions as Thursday's, Chez Georges and Les Halles, among other restos. "I learned the importance of speed at Thursday's, the importance of public relations at Chez Georges and the importance of service at Les Halles," he says. "I came here almost by accident. Then I met Jacques (owner Muller) and was captivated by his approach. He was and will always remain the soul and spirit of Le Mas. He taught me to listen to clients and to be flexible to their needs. That is our strength."

Like Varo, Blouin, too, could write a book on what he's seen and heard here. He won't. "Our customers trust us. We are not trendy here. Some say we're blue-chip. But other restaurants come and go, and we'll still be around ten years from now. We pride ourselves on the fact that more than sixty per cent of our customers come back—over and over again."

One of those is notary Robert Senécal, who makes the pilgrimage from his West Island office four times a week for lunch—almost exclusively at Varo's bar. "I arrange my business appointments around my lunches at Le Mas," says Senécal. "This is one of life's priorities for me. I also took the decision not to work Friday afternoons since I was forty, so I could really enjoy my end-of-week lunches here. In the old days, I had to come into the city to go to court for records, which is how I ended up at Le Mas. But today with the Internet, I don't have to do that anymore." That he continues to trek into town anyway shows just how much dedication Le Mas inspires in its customers.

It's all about the camaraderie here," Senécal explains. "Sure, this is a great place to network for business, but that's not what brings me here. It's the people. And, of course, it's Elise (Varo). She knows pretty much everything about me. She's also the one who introduced me to the love of my life."

That happened on a day, ironically, in which Senécal had gone to lunch elsewhere. But it was his birthday and Varo insisted he drop by

for a cocktail and to pick up a card she had for him. "There were two gorgeous women sitting at the bar," recalls Senécal, who was divorced at the time. "I figured they must be married, and even if they weren't, they looked too rich to be interested in me."

Turns out one was a widow, and was as smitten by Senécal as he was by her. They've been together ever since.

The normally circumspect Blouin, overhearing this conversation, comes forward with his own love story. "It was eight years ago. I was at Thursday's and, at the same table where I had met my first wife twenty years ago, I was hit by a thunderbolt and met Nicole. It was love at first sight. I knew instantly she was my soulmate. Six weeks after meeting her, I asked her to marry me. Five months later, we were married. We are together constantly. I am the happiest person in the world. I have no complaints. In another life, we will be together again. I can hardly wait."

So one comes to Le Mas in search of political dirt, and one goes away with tales of sweet romance. "Really," says a smiling Blouin. "That's just so Montreal."

[Le Mas des Oliviers, 1216 Bishop Street]

1:00 p.m.

PIERRE AND MARY COSSETTE are holding court at their customary table at Leméac. It's 1:27 p.m. They are extolling the virtues both of Leméac and Montreal to a couple of visiting Californians, as well as a couple of native Montrealers who are not so well tuned in to the town. "What's strange yet amusing is that we end up telling more Montrealers about the city and its plethora of attractions than we do tourists," Mary explains between sips from a goblet of a superb Morgon.

The Cossettes are among the most informed and the most enthusiastic boosters of Montreal you'll find. What's a little unusual is that they have spent much of their lives in California. The eighty-three-year-old Pierre was born in Valleyfield, west of Montreal, but was just three when his family moved to the sunny southern state. It was only after he married Mary, a bona fide Los Angelina when they got together twenty-four years ago, that he returned to his ancestral roots in Quebec and the couple began spending about half the year here. They have a home in St. Anicet, a tiny hamlet on the St. Lawrence River about thirty kilometres from Pierre's birthplace. The rest of the year is spent shuttling between residences in Beverly Hills, Palm Desert and New York City. So when the well-travelled Cossettes make comparisons between Montreal and other places, they know whereof they speak.

Typical garb for Pierre Cossette is a weathered old cap, non-designer sweatpants and sneakers—which is what he's sporting today while chowing down on a plate of calamari. With his trademark beaming ear-to-ear grin, he looks like an oversized teddy bear, a kindly granddad. But appearances can be awfully deceiving. While this unassuming gent is in fact a grandfather, to musicians far and wide he is known as the Father of the Grammys.

Pierre's is an intriguing tale: It was back in 1969 when he first approached the National Academy of Recording Arts and Sciences to

purchase the rights to televise the Grammy Awards. After much wrangling and hair-pulling, two years later Cossette got his wish and produced the Grammys on the tube for the first time.

Prior to Cossette's involvement, the Grammy Awards ceremony was held in hotels and in front of small crowds, generally consisting of a few performers and their occasionally exuberant families. Times change. Now the Grammys are staged only in the big rooms, and the telecast is watched by a billion viewers around the world. Virtually every star in the biz will show up. Few need coaxing, for the Grammys are to the music biz what the Oscars are to the movie biz.

Looking back, "it all starts with a desk, a telephone and a waste basket, and then it mushrooms into the single largest entertainment production on television," Cossette is fond of saying. "But, frankly, I never would have believed this would be possible."

Let's just say that back in '71 TV execs weren't exactly wild about the prospect of televising the Grammys. "They thought I was completely nuts trying to produce a live-music show featuring what they called long-haired hippies with earrings and high heels. Don't forget, Perry Como and Jack Jones were the big superstars to these people back then. And the only reason I was able to sell it to ABC for the first year was because I got Andy Williams to host."

The first show went off without a hitch, even though Cossette had to go out onto the street and lure people inside to fill the 600-seat Hollywood Palladium. And Williams ended up becoming Cossette's best friend.

When ABC got cold feet about broadcasting the Grammys from Nashville two years later, Cossette pleaded with CBS to leap into the fray—otherwise he was cooked. The strategy worked and the Grammys have been on CBS since then.

Even by Hollywood standards, Cossette's ascent in this world plays like one of your more far-fetched Cinderella tales. In 1926, his family up and left Valleyfield and Canada for the Lotusland that is California— without any connections to greet them on the other side. With the onset of the Great Depression, Cossette's father didn't fare well, losing his job at a lumber company and later eking out a living as an attendant at a gas station.

But the kid had dreams and a lot of moxie. His first venture into show biz came when he snagged Red Skelton to do a show at his high school in Pasadena. After a stint with the U.S. Army overseas during the Second World War and then after graduating from the University of Southern California in 1949, he landed a job with MCA Records to book talent for the college circuit and later for the casinos in Las Vegas, Reno and Lake Tahoe. And with an MCA talent roster consisting of Frank Sinatra, Lena Horne, Nat King Cole, Bing Crosby, Judy Garland, Dean Martin and Jerry Lewis, Cossette had little difficulty convincing the casino-owners to do business with him.

He later diversified into stage and TV production. In the early '60s, he mortgaged himself to the max to co-found a record label. In retrospect, it was a good investment. Dunhill Records hit paydirt with such artists as Johnny Rivers, the Mamas and the Papas, Barry McGuire, Steppenwolf and Three Dog Night.

About the same time the Mamas and the Papas had the No. 1 album on the pop charts, Cossette paid a visit to relatives in Valleyfield. "I was really embarrassed, because my Aunt Thérèse started introducing me around town—but something got lost in the translation. They thought I was a disc jockey and a really nice guy, because the first thing I did when I got famous was to make a recording with my maman and papa," Cossette recalls.

It was in the same neck of the woods that a few years later Cossette first spotted a young, unknown recording artist who blew him away. "She was represented by CAA (Creative Artists Agency) at the time, but they had no idea what kind of talent Céline Dion was. I wrote to Mike Ovitz (head of CAA at the time) and told him she would be the next Barbra Streisand." He wasn't far wrong.

Cossette Productions, which he runs with his son John, has been one of the world's most dynamic entertainment production houses for more than fifty years. The company has also diversified dramatically over the years. In its early stages, Cossette Productions was involved in talent management and oversaw the careers of some of the biggest celebs in the business. Cossette Productions has since branched out to produce the equally celebrated Latin Grammys and Black Entertainment television awards show annually. The company has also been

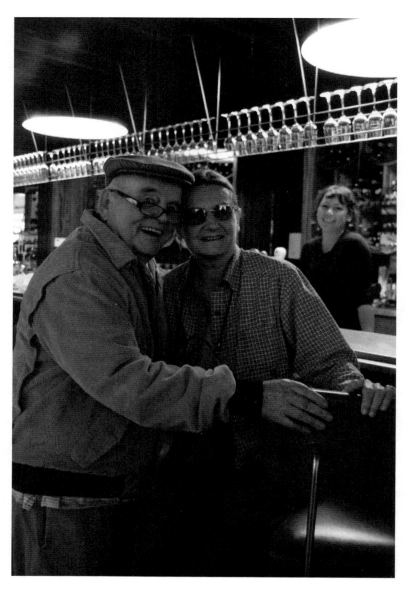

Pierre Cossette serenades bride Mary at Leméac.

responsible for producing Céline Dion's TV specials, not to mention such blue-chip broadcasts as Central Park Live and the Kennedy Awards Gala, among a host of others.

Cossette Productions also managed to strike gold in one of the most volatile spots, the high-stakes world of Broadway. The company produced The Will Rogers Follies, which won a slew of awards including the Tony for best musical. It also produced the acclaimed Scarlet Pimpernel and The Civil War, both of which were nominated for Tony Awards in the best musical category.

And while he has slowed down a tad, letting his son Johnny assume the reins for the company, this is not to suggest he's retired. Over lunch at Leméac, Pierre and Mary are making plans to bring a musical on the life of Woody Guthrie to Broadway. It has already had hugely successful runs at Edinburgh's annual Fringe Festival.

"But enough about us," says Mary, while knocking back a Malpèque oyster. "We're foodies. We've been to the best and apparently the most interesting restaurants in New York and California, but Montreal is as good as it gets. There's ambience. There's laughter. And there is, mercifully, precious little heated conversation about politics at the table. Everyone in the States is polarized and everything is about politics, or so it seems. And if it's not that, it's about religion. And what's more, everybody in restaurants in the States seems to be on their cellphones. What has happened to the dining experience there? Look around here. Do you see anyone talking on the phone? Do you hear the annoying rings of a cellphone? No!"

Despite growing up amid the hustle of L.A. where Mary lived with her mother and stepfather, president of Paramount Pictures' distribution arm, meals were sacred for the family. No phones. No politics. No religion. No star gossip. "And probably no talk about sex," Mary cracks. "We had long, leisurely dinners and we focused on the food.

"In Montreal, I've never felt rushed," she adds. "And we don't get servers who come up to us and say: 'Hi, my name is Jerry and I will be your waiter for the night,' and then want to tell you their life story. We don't care. We don't want a new best friend as our waiter. We want to be courteous but we've come to eat. Servers here seem to understand that. They don't push. They want to give you the ultimate restaurant

experience." Pause. "And another thing. Unlike New York, here they honour reservations for the time you've made them. We don't end up spending two hours waiting for a table. I don't think most Montrealers appreciate how wonderful their restaurants are. This explains on one level my love affair with Montreal."

His plate of calamari cleaned up, Pierre takes over and allows Mary time to dig into her steak tartare and the most "sinful" frites around. "Montreal ranks up there with San Francisco and Rome as the most beautiful cities in the world," he rhapsodizes. "But Montreal has replaced them both as the most sophisticated city. This is also the most avant-garde city I've ever been to: the music, the art, the theatre, the restaurants. There is so much talent here, and it's so diverse, which probably makes it the most cosmopolitan city in the world, too. Best of all, though, people for the most part really seem to love life here and aren't at each other's throats."

For the record, Pierre hasn't been drinking. Nor is he a paid shill for the city.

"Can't forget the humour here," Mary jumps in. "People are always laughing—for reasons that aren't always obvious. There is just this joie de vivre here, the kind you don't even see in Paris. Really, did you ever see DeGaulle smile?"

Come to think ...

"I think it has to do with people being comfortable in their own skin," Mary continues. "People here appear comfortable but not overly cocky. Few try to impress you or prove something to you. They just let you be."

The Cossettes have since been able to turn their friends, like Andy Williams and Bob Newhart and their respective wives, on to the city. "We'd spend more than half the year here if we could, but we'd probably get tossed out on our derrières for doing so," says Pierre, in reference to matters pertaining to tax and health insurance.

"Sure, California has the climate, but the brains of many of the inhabitants have turned to mush. Too many people talk too much about their plastic surgeries and their next plastic surgeries. People in Montreal appear to age gracefully."

Mary prides herself on not being a slave to style or plastic surgery.

She wears her hair in a ponytail and eschews the frocks of the in designers. Yet she marvels at how Montreal women are able to put themselves together so well on a budget that wouldn't get most Californians she knows through a day. "Plus, they manage to make it out alive through hard, cold winters, and still look great."

Okay, guys, the gushing over the city is great. But some of us feel it is our duty to point out a few of the city's shortcomings.

"Crazy politics and politicians?" Pierre blurts. "Let's just say you have no idea what that's really like. Traffic? Sure, it can be a nightmare at times, but you haven't really seen bad, bad traffic until you've tried to negotiate the streets of New York or London."

At this point, I'm looking under the table to see whether Montreal's Mayor Gérald Tremblay is hiding and sending them signals. It's possible, since Leméac is one of Tremblay's favourite haunts—although he tends to drop in after ten at night when the prices drop significantly.

But no Tremblay to be found, and the Cossettes say they've never met the man. Furthermore, Pierre's next comments would seem to indicate he's not on the mayor's payroll: "What I think Montreal is really lacking is a strong leader, like New York's Michael Bloomberg, who can rally people and get them to work for the greater good and to instill in them more civic pride. Not just the people who live in the city, but the people who work for the city. I don't really think most Montrealers appreciate what a cool place this is and how much cooler it could be—and I ain't talking winter here." Pause. "And the women ... I've never seen anything like Montreal women anywhere in the world— in Hollywood, Paris anywhere."

Pierre believes it was some spiritual force calling out to him in California that got him to return to these parts. "I felt that something was missing in my life in California and New York. I couldn't put my finger on it. Then by chance, just after I met Mary in 1983, we came up here on a whim. And it came back. I was only three when I left, but my roots are French-Canadian and I always felt different in the U.S. My body may live in the States, but my soul is in Montreal. I feel truly at home here. People seem so happy and so much less intense here. People seem to understand me, even as I grapple with my French—which gets better all the time."

The plan now for the couple is to set up a Cossette Productions office in this city, both to focus on theatre and TV endeavours as well as to scour for, who knows, the next Céline. And they are not afraid of scouring. It was after hearing a teenage Céline sing at a regatta in Valleyfield and then at the Rustik restaurant in Châteauguay that they put the word out about her potential. And of course it was Pierre who arranged for her to give her first performance at the Grammy Awards—first but far from last!

"Can we talk about oysters?" Mary interjects. "These are the best. They come from the East Coast. In L.A., they have no clue about good oysters. These Malpèques are orgasmic. And speaking of orgasmic, the restaurants, hotels, art galleries and antique shops of Old Montreal are up there, too. Our house in L.A. is full of Quebec art and pine antiques. People have never seen anything like it."

"That's why Montreal calls out to our hearts," Pierre says.

Overhearing this homage is Leméac waitress Stephanie Mendoza. "Well, California is calling out to my heart," she says. "I need the sand between my toes especially during winter here."

"But only for a short break," Pierre urges her. "The place can kill you if you're not careful."

The music of Tony Bennett is playing in the background. As is his wont, Pierre starts warbling along to the lyrics. "I gave him his first break in Las Vegas," Pierre tells Stephanie. "He opened there for Harry James."

Stephanie has heard of Bennett. It is clear she has never heard of Harry James.

"Ask your mother," Pierre says. "No, ask your grandmother." Pause. "Those were the days in Vegas—for me, anyway. But these are the days for me now. That's what keeps me going."

[Leméac, 1045 Laurier Street W.]

2:00 pm

MIKE PATERSON IS SPORTING gi-normous aviator-style reflector sunglasses. His fingernails are painted a garish red. Even at the Copacabana, where anything goes, Paterson stands out, albeit sitting down. Paterson, comic, lip syncer, actor and star of TV commercials, is a dead ringer for John Belushi. And come to think of it, with Belushi being dead and all, Paterson just may be his reincarnation. Physique aside, Paterson also bears a strong spiritual resemblance to the late/great samurai comic, who brought new meaning to the concept of lifestyle abuse.

Paterson claims to be working out at a gym these days and riding his bike through wind and sleet and snow. He also claims to be the world's fattest vegetarian. Much beer and bread will do that to one's girth.

It's 2:11 in the afternoon. Never too early for a Paterson family reunion at the Copa ... Copacabana Maybe it's not the hottest spot north of Havana, but say this for Montreal's Copa: few can beat it when it comes to cheap hooch and to Indian grub homemade by a white man from the 'burbs that are Hudson. The Copa is home to city bohos and journos—specifically such swell free spirits as Hour's Jamie O'Meara and Bugs Burnett. Artistes and would-be artistes of all stripes congregate here, too. The Copa also boasts waitress Maya Merrick, who can outwrite the majority of her clients. She has just penned her second novel, *The Hole Story*.

And the Copa is home to gonzo comic Paterson. This afternoon, Paterson Power rains down on the joint. Mike is joined by his writer bro Mark and his ex-wrestler bro Nic and his would-be bro Tim Rabnett, a comic and lip syncer who sounds and acts more like Mike than Mark or Nic do.

The Patersons' poison of choice is gin and tonic—save for the more corpulent Mike, who needs his brew. It doesn't take long for the

other bros to notice Mike's shrieking red fingernails. "It's for a gig I'm doing tonight as Michelle Paterson," he protests. The brothers aren't convinced. Albino Fernandes, the avuncular co-owner of the Copa for the last fourteen years, isn't entirely convinced either, but he knows better than to judge his regulars.

"They're all good kids, even if they dress and act differently," says Fernandes, who looks like he might have been a welterweight fighter in another life. "They are well-behaved for the most part. They're like my kids, really."

One of those kids is no longer here. Ryan Larkin, not young but who always seemed to look and act like a kid, passed away recently, and Fernandes still grieves for him. Larkin, a renowned Oscar-nominated National Film Board animator in his day, hit hard times and became homeless—save for his ringside table at the Copa—and yet became the subject of a film that won the Oscar in 2005 for best animated short. The gentle panhandler would act as a kind of doorman at the world-famous Schwartz's deli, just across the Main from the Copa, and after a few hours on the job he would head to the other side of the street, earnings in hand, and blow it all on the booze.

"I would offer him food all the time, but he would just smile and say all he wanted was drinks," Fernandes recalls. "He was a very sweet man and I miss him so much. He had such talent, too."

Fernandes is under no illusions about why folks like Larkin flock to his place. Sure, those concrete palm trees have a certain cachet. Same, too, for the Brazilian beach motif showcased on the murals as well as the bar and table tops. But before Fernandes can spill, Mike Paterson pipes up: "It's the prices. Damn good. And it's dark here. But not dark enough to conceal my red fingernails."

"And, can't forget, there's lots of padding around the bathroom and other places, just in case we fall," adds Nic Paterson, who as a former rassler is keenly aware of the merits of padding.

"For me, though, the big attraction is the giant shish taouks," says Mark, the author, in reference to the faux palm trees.

"We really have two kinds of customers: students by night and career drunks by day," cracks Fernandes. "But sometimes the drunks stay into the night, and the students start earlier in the day."

Back to the Patersons. They could be a sitcom, albeit more bizarre and funny than anything on mainstream TV.

Though he is one of the city's most acclaimed comics, though he has starred in a variety of TV shows (who can forget the kiddie show *Surprise! It's Edible, Incredible*), though he has lip-synced his way to glory (with would-be bro Rabnett and comic Ryan Wilner in the hysterical combo Never Surrender), though he has actually sung (with Rabnett in the Dan-d-Lyons), Mike finds it somewhat befuddling that he is more recognized on the street for his short-lived yet obviously memorable Jig-A-Loo TV commercials, wherein he greased rusty garage doors. Nic, on the other hand, has made a drastic career change: he has morphed from wrestler to Internet business reporter. And then there's Mark, the sensitive and respected writer, who recently launched his second collection of short stories, *A Finely Tuned Apathy Machine*.

The book launch at the 3 Minots, just down the street on the Main, was unlike any in this town. But there were no casualties.

"Nic promised not to hit anyone over the head with a chair and he kept his word," says Mark, thirty-five. "On the other hand, Mike and Tim did write and perform a special song for the launch. It was called Wait for the Movie, which was not exactly the message I wanted to send out. My brothers did what they could to disrupt the launch, but I've got to hand it to them: they made the literature part easier to swallow. I even managed to sell thirty-three books—in spite of them."

"Sure, we are different in some ways," allows Mike, thirty-three, over his second pint of brew. "For example, Mark is a vegan, I'm a vegetarian, Nic is a pescatarian and Tim is a pig. But combine us and we make for one powerful force."

For the record, he's talking creative, not gastric, force here. He's talking Paterson Power.

The bros are fiercely proud of Mark, but feel he's perhaps too understated. So Nic wishes to extol his brother's writing virtues: "He is an expert at dealing with uncomfortable food situations featuring severed hot dogs, pizza sauce, chicken paprika and, of course, sex."

Truth be told, Mark can turn a dark and twisted and hysterically funny phrase with the best of them, and his second story collection, like his first, *Other People's Showers*, strikes many a nerve with its

delineation of the agony and ecstasy of dysfunctionality—his understanding of which can no doubt be attributed to his family.

"It's funny, though, that Mark's writing is so edgy when he's really the responsible one in the family," says Nic, twenty-seven. "He's the family guy with a wife and two young kids. He's a rock in so many ways. Really, I think my only good quality is that I'm usually punctual—especially when there is a cheque to pick up. Off the top of my head, I can't really think of any admirable qualities about Mike or Tim."

"Mark is a family guy, yet his writing really shocks me," says Mike. "It's weird how someone as nice as Mark can be so dark."

"And Mark's wife is a financial rock," says Tim, twenty-nine. "She used to have to wear earplugs whenever we came over. That's because she was always studying. It paid off. Now she has a car and a job. She also showers regularly and uses real soap. Which is more than I can say."

So what sayeth Mark? "As far as Patersons go, I guess I'm the most stable. I pay my rent and taxes on time. I eat three meals a day— which contain more than liquid. My wife supports me emotionally. I try to contribute financially by doing some translation and writing radio commercials, in addition to my writing. I drive my five-year-old twin girls to and from school every day. By the way, they are more mature than Mike but just as mature as Nic and maybe as Tim."

Mark claims to have been bitten by the writing bug as a young kid. "When I was five, I would write and illustrate dinosaur books, stapling them together and then sticking them on the shelves of our local library. At the time, I thought that was the way to get your books in a library."

Writing runs in the family. His dad wrote poetry. And even Mike penned, in longhand, a novel, while he worked as a manual pin-setter at a bowling alley and took, perhaps, a few too many errant pins to the cranium. "It's a plot-heavy zombie novel," says Mike. "I asked Mark to read it, then type it. It's 650 pages long, so I guess he hasn't finished yet."

Mark feels that family dysfunctionality set in long before Mike started working as a pin-setter. "As kids, our parents forced us to do a lot of fashion shows, because we had no sisters. Then we were forced to watch the movie *Grease* all the time. We also had huge stacks of *Mad* magazines around the house. Plus, we mostly ate pizza. Maybe that explains the path I've taken."

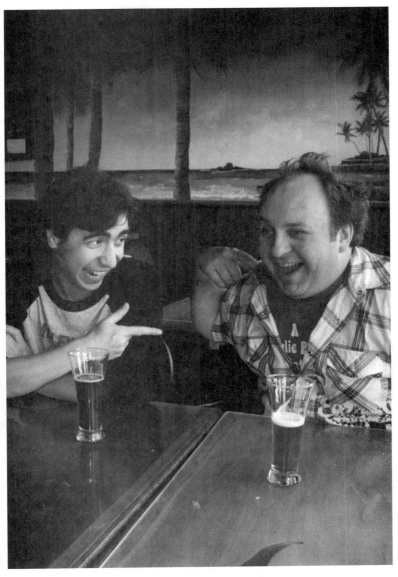

Mike Babins and Mike Paterson talking Tolstoy ... not!

The Patersons are distracted by some form of extreme fighting being screened on the Copa's giant TV. They turn to the authority on the subject of all matters grappling. "It's Mu Tai fighting," Nic explains. "It's a mix of kick and regular boxing, and if you had any real teeth going into the ring, you wouldn't when you left it."

Nic describes his former vocation as fake wrestling. He played the character of a ruthless manager. "I was better at talking than wrestling in the ring, but I still managed to get hurt a lot. Once I ended up with barbed wire stuck close to my eye."

"People really hated Nic in the ring," says Mike. "They would spit at him and everything. I was so proud of him."

"I was actually the first wrestler to spit back," counters Nic. "I like to think I gave something back to the sport."

"And Nic could really sell pain, too," says Mark. "He was a great actor."

"Actually, I wasn't acting," retorts Nic. "I was in pain. That's why I switched careers. I remember thinking about eight years ago that I was going to take the world by storm. I'm still waiting. So now I'm pursuing a broadcast career with no broadcast experience other than watching Access Hollywood and wrestling announcer Mean Gene Okerlund."

Mike raises his arm. Yes, Mike? "I have a joke," he says. "How did the Greeks win the war? A sneak attack from the front." Pause. "I stole that from my Uncle Perry."

"How did the Greeks win the World Cup?" asks Nic. "They came from behind."

Mark merely shakes his head. "My daughter asked me to Google Google. How clever is that? She really is smarter than Mike."

"No argument there," says Mike.

"I think I'm finally going to win Paterson Son of the Year this year," says the previously silent Tim. "Just as soon as the official adoption comes through."

"I'm hungry," says Mike, the rotund vegetarian. "I feel like eating croutons the size of my head (which, for the record, is large). I feel like drinking a lot of beer, because beer is not meat. That's why I love the Copa, too. Cheap vegetarian eats—apart from the beer."

This brings a smile to the mug of chef Jay Taylor, the refugee from

Hudson who has been cooking Indian veggie delights at the Copa the last five years. "Really, what goes better with cheap beer than cheap eats?" Taylor notes. "We have a real niche market here."

At the table behind the Patersons, a trio of transplanted Peruvians has moved in. "We have not come to eat," announces their spokesman Juan-Pablo Gonzalez, a waiter at a Portuguese resto up the street. "We do not like to drink a lot." Pause. "But we do not like to drink a little, either."

"Now, that was funny," says Nic Paterson. "I used to do comedy and tried to make a minor comedy comeback earlier this year. Then I injured my knee doing comedy."

"Thus ending a minor comeback," says Mark the insightful. "A tragedy. Sort of."

Oh, joy. There must be a full moon in the offing. How else to explain the sudden presence of another of this city's most engaging eccentrics? That would be Mike Babins, alias Mike Metal, alias The Randomyzer, alias Johnny Jackoff, and soon-to-be-alias Johnny Suede, lead singer and loon for the soon-to-be band The Slicks.

"So who are you really?" Paterson asks.

"I'm Jew ... ish," responds the Metal alias.

Mike Babins is a producer of the popular Dave Fisher weekend morning show on CJAD. Mike Metal spins heavy metal tunes at the midnight hour on Fridays on CHOM. Johnny Jackoff is the former lead singer and loon of the almost legendary Montreal punk band The Vaginal Croutons, among whose other members were Kip Rectum, Spongy Crackers and Asbestos Felt. The Randomyzer is a disco deejay who dresses up in colourful polyester attire and does deejay work for the likes of Bjorn Again. Johnny Slick is to become an amalgam of all of the above.

As fate would have it, Mike Paterson is well acquainted with the Mike Metal alias, being a fan of the Friday-night metal music broadcast. When the two met at a comedy show in which Paterson was performing, "his first reaction was: 'You're Mike Metal!' and he couldn't stop giggling. Then he went up on stage and announced that Mike Metal was in the crowd. And he started giggling again. I became his punchline," reports the Metal alias, who is drinking from a bottle of fluid which just may be full of vodka.

Eying the bottle, the ever-astute author Mark Paterson theorizes that Babins's frenetic mutliple-personality life "probably explains why you're an alcohol ... ish."

Mike Paterson, he of the penchant for croutons, wants to know about the roots of The Vaginal Croutons.

"Simple," shoots back the Johnny Jackoff alias. "I got booked to do a show based on the name I had made up. This forced me to spend the afternoon before the show writing some songs for the Croutons. We only performed for twelve minutes that night because I was only able to write four songs. We called the show our Reunion Tour even though we'd never existed before. We even sold Vaginal Crouton panties."

"I think I may have bought some," says Mike Paterson. "But even though they were larger than my head, I wouldn't have eaten them. I'm a vegetarian and I can't eat cheese."

Thanks for sharing.

The Vaginal Croutons have since called it quits. "It's the end of an error," says the Johnny Jackoff alias. "But what times we had."

Indeed. The Croutons have the distinction of being the only band to have ever been kicked out of the Jailhouse punk venue. Apparently, management objected to the boys turning the stage into a giant bubble bath. They were also one of the precious few acts ever tossed from Toronto's famed El Mocambo. The Croutons weren't paid, so they simply trashed the place

On the plus side, the guys opened for such legendary—often in their own minds—punk ensembles as the Misfits, Skid Row, Vince Neil, the Hanson Brothers and the Killer Dwarfs, and were featured in a film with the late and large Wesley Willis. And their last disc, Obscene Cuisine, sold in the dozens.

"Don't forget we also grossed out Geddy Lee and we seem to have impressed Tommy Lee. Plus, a right wing group protested our show in Vermont," gloats Jackoff—who has always insisted his last name was shortened from the original Jackoffsky.

The Randomyzer, on the other hand, hasn't been shortened from anything. After lying low and strutting softly for the last few years— something about an altercation at a downtown club with an irate customer, overserved by booze and over-agitated by the Bee Gees—the

Randomyzer, arguably Montreal's premier disco diva, sprang back to life recently as the opening act for Bjorn Again, the band of Abba revivalists from Australia who are arguably better than the Swedes they imitate. Under a massive and sparkly mirror ball, the Randomyzer spun disco hits from the '70s.

So what kind of deal did Randomyzer cut with Bjorn Again? "Let's just say I negotiated a cheese sandwich. Randomyzer loves cheese. And Randomyzer is a vegetarian, too," he tells Mike Paterson.

"My girlfriend really hates your show," Mike Paterson informs the aliased one.

"Thanks. Which show?" asks the aliased one.

"Mike Metal," Mike Paterson replies. "She hates it because I stay at home on Friday nights at midnight to listen to you instead of taking her out to somewhere romantic."

"I don't blame her," says Mike Metal. "I'm in love now. I'm even using the 'L' word with her. We fell in love at an Ultimate Fighting show."

"Now that's really beautiful," says Nic Paterson. "Love and fighting can mix."

"I'm thinking of marriage myself," reflects Mike Paterson. "I was just at a wedding and was quite moved. And I wasn't drunk, either. Because it was a cash bar."

Everyone around starts laughing.

"That wasn't meant to be a joke," Mike Paterson announces once the laughter has subsided. "I'm thinking of turning my life around. It won't be easy."

"Know what you mean," says the suddenly sensitive Mike Metal, or perhaps it's Babins. "I'm a slacker, too. I may work twenty-two hours a day, but I don't sit up straight."

"I have to work really hard, too, to maintain my freestyle slacker lifestyle," says Mike Paterson. "We could have been separated at birth. I get up in the mornings now. It's insane." Pause. "By the way, do you have any Varsol on you? I have to get this red polish off my nails."

[Copacabana, 3910 St. Laurent Boulevard]

3 p.m.

A LITTLE INTELLECTUAL STIMULATION mixed with a little lively overview on the state of the universe, or perhaps just of Montreal, over a glass or two of pinot noir at 3:18 in the afternoon? No problem. If the gonzos like to unload at the Copacabana, the deep thinkers like to let loose at Café Cherrier on St. Denis Street, the practically perfect bistro that can take on the best Paris has to offer. Where clients can linger over a glass of wine, unharassed, for hours on end. Where clients can be caught sketching and scribbling and saving the world. Or prognosticating and pontificating. Or, perhaps, even romancing and engaging in some understated canoodling. In short, it's quintessential café culture.

And should anglos from west of the Main wish to know what francos are thinking—socially, politically, culturally—the Cherrier crowd is the ultimate barometer, and has been since the place opened in 1983. It is on the itinerary of artists, academics, actors, writers, broadcasters and politicos, only too willing to share their opinions.

Whereas ever-cynical anglos talk of reasonable accommodations in terms of finding room rates on the level of a Motel 6, ever-philosophical francos take a decidedly different tack in discoursing on the necessity of preserving a culture. As is the case with a couple—anglo male, franco female—shmoozing at a corner table. The fellow, beer in hand, goes on to pronounce that he's against same-sex marriage: "I don't want the same sex all the time," he cracks. "I want a little variety." The lady, delicately holding her demitasse of espresso, merely sighs. Then they kiss—not overly tenderly like some newly formed love unit, but with enough feeling to suggest this relationship has been on for a significant period and will likely last longer.

Denise Fortin is one of those contentedly sitting solo, scribbling her thoughts into a journal. A recently retired medical archivist, she makes the trek—about 45 minutes—from her apartment in the Côte

des Neiges district to Café Cherrier in the Plateau several times a week and she has been doing this the last ten years. Sometimes she comes to unwind with friends and former colleagues. Sometimes to share thoughts with her Italian-Canadian boyfriend. And sometimes, like today, just to gather her thoughts and enter them into her diary. This day's entries relate to family conflicts, "trying to come to terms with those with whom it has never been easy to relate—but with the passage of time, it's important to make some peace and to put some closure on the issue."

The petite and genial Fortin admits, though, that it's hard to focus on interpersonal difficulties while gazing outside at the fabulous display of colours provided by the autumn, magnificently framed by the afternoon's majestic lighting.

Perhaps it's the talk of colours and light that leads to a conversation about the state of cinema. Fortin is bullish about Québécois cinema, but feels far too many Quebecers have a bias. "Even most francophones, it seems, would rather watch some inferior film from Hollywood or France than to see something homegrown and unique from Quebec," she says. "It really annoys me, because if we don't support our cinema, nobody else will, either, and it will disappear. We have such a rich history of fine film, but it's sad that not many people appreciate it."

With that declaration, Fortin pays homage by listing some of the great contributions to Québécois cinema over the years: Denys Arcand's Oscar-winning *Les Invasions barbares* as well as the film that spawned it, *Le Déclin de l'empire américain,* plus his *Jésus de Montréal* and his earlier *Réjeanne Padovani*; Jean-Claude Lauzon's *Un Zoo la nuit,* Claude Jutra's *Mon Oncle Antoine* and *Kamouraska*; Francis Mankiewicz's *Les Bons débarras*; Yves Simoneau's *Pouvoir intime*; Michel Brault's *Les Ordres*; and more recently Jean-Marc Vallée's *C.R.A.Z.Y.*

"People who seem otherwise intelligent are prejudiced against their own culture," Fortin continues. "We should be proud. We shouldn't be ignoring our culture. I don't think the situation is much different in the rest of Canada, either. People seem to have an inferiority complex about Canadian cinema, too. Judging by the box office statistics, Canadian films don't do nearly as well as American films, which don't have nearly the same integrity. It's too bad. If people can't learn to love

Café Cherrier bartender equally adept at dispensing wine or philosophy.

their culture, how can they love themselves?"

As is so often the case, conversations about culture in Quebec lead to conversations about identity in the province. Like the ever hot-button issue of reasonable accommodation. "I think a recent immigrant from the Middle East put it best: when one moves to another country, one should accept and respect the culture of the people. If not, why choose to come here? I have nothing against immigrants coming here, but I think they should make an effort to interact and to have an entente with the people already here.

"In the case of Quebec, I think it's doubly important, because we have to preserve a culture that will always be a little fragile in North America. Everyone is entitled to their beliefs, but we also have to find some common ground if we are all going to live together in harmony. I think it's terrific that more and more Montreal anglos speak to me in French and express their love for living here," says Fortin, pausing for a sip of her white wine. "What's funny is that we worry so much about losing our language. But now I feel bad that I don't speak English at all, yet most of the Montreal anglos I meet now are so fluent in French."

Not surprisingly, talk of language neatly segues into religion. Fortin brings a perspective to the table that is oft overlooked by the English and, often, the French media in Montreal, too. Fortin was born and raised in the small community of La Pocatière, down the St. Lawrence River. "My earliest recollections of life then was that the church was all-powerful. It controlled not only the religious and cultural aspects of life, but the political ones as well. Many believe that religion was a block and kept us down in life. But we have since escaped the shackles of our religious conservatism, to the point where our culture has evolved and we don't feel as suppressed.

"So it's confusing for many of us to see the rise of rigid and conservative religious beliefs of immigrants who are moving here now," she adds. "Honestly, it scares me. I have always had a philosophy of live and let live. But when I see things that remind me of my past, I worry that history might repeat itself. And I particularly worry that, after women have made such inroads in society, religious conservatism will hold them back. I have travelled around the world and I respect the cultures of others, no matter how different or how much more conservative

they may be than mine. But I just wish people who come here will act in the same fashion."

Next it's on to economics. Fortin notes that the financial power-base has dramatically shifted in the last few decades. "Money has always been the root of most woes. And money has always gone hand in hand with power," she says. "In the old days here in Quebec, it was the anglos with the money and, consequently, the power. Now, it's quite evident that there is a strong and mighty franco economic power-base here."

And where else does a discussion on economics and power lead? Politics, natch. "I make no excuses," Fortin announces. "I am a sovereignist. I support the Parti Québécois and the Bloc Québécois. I respect and admire Canadians. But we're different. We can live side by side in peace, but I think it would be easier for all concerned if we were two separate entities. Even my anglo friends here feel distinct from Canadians in the rest of the country. They don't understand us and we don't understand them. And by us, I mean all of us who choose to live in Quebec: anglos, francos and allophones. There is no distinction. Despite what some might say, we are all Quebecers.

"The debate may go on another fifty years, and nothing will be resolved in terms of independence. But that could be the result of our leaders. We lack leaders with the charisma of a René Lévesque or even Lucien Bouchard, who could rally the troops, who believed in an all-inclusive Quebec. Today, it's all political posturing to get into power. Our leaders are transparent and don't have the same credibility with the people." Pause for another sip. "The beauty of the people here, though, is that regardless of the final outcome, life goes on. And despite differences, Montrealers can mostly all agree on one thing: that we love to have a good time—talking, partying or both. And, another thing, it is my humble opinion that Montreal is the greatest city in the world."

Fortin goes on to cite the usual reasons: the restos, the arts, the architecture, the ambience and, yes, the city's rich array of cultural communities. "One can get to travel the world and never leave this city," she notes. "In the old days, you would have to go to Paris to get this kind of bistro/terrasse life. Well, this is better than Paris and it's safer, too.

"It took events like Expos 67 and the Olympic Games of 1976 to

make Montreal aware of the rest of the world. No question, the Olympics cost us a lot financially. Mayor Jean Drapeau had some great ideas, and the older we get, the more grand our ideas become; but we don't necessarily get wiser with age. But, to his credit, Drapeau wasn't a bureaucrat like so many of today's politicians and, also to his credit, the rest of the world has now become aware of Montreal."

[Café Cherrier, 3635 St. Denis]

4:00 p.m.

If you look under "lavish" in your illustrated dictionary, there should be a photo of Hôtel Le St-James.

Good grief. "Boutique hotel" is too downscale a term to describe this five-star establishment on St. Jacques Street, in a building that was formerly the Nesbitt Burns brokerage house and, before that, the Merchants' Bank. After three years and "many, many, many millions of dollars" in restoration, this is the poshest of the posh, making the Ritz Carlton look like a youth hostel.

Think Versailles. Think guillotine for any non-unionized staffer who would dare disrupt service. Think ornate marble and mahogany and candelabras and antiques and paintings from centuries past. Think multiple flat-screen, 42-inch plasma TVs and Bang & Olufsen CD players in every suite. Think every amenity imaginable—and then some. Hell, even the room keys have fancy tassels that just might set one back a few grand. And think about a loan from your friendly bank manager should you entertain any notion of spending a night in one of the hotel's sixty rooms, ranging in price from $400 to $5,000 for a 4,800-square-foot suite that is almost the same size as Versailles. No surprise that the hotel has the highest average hotel rate—$595—in the country. In light of this, perhaps it's more of a surprise that the annual occupancy rate is between 75 and 80 per cent. And, for the record, room rates don't include taxes or continental breakfast.

"If you have to ask the price, then the St-James is probably not for you," the hotel's former general manager, Elizabeth Glimenaki, diplomatically and delicately suggests. "No one objects to the prices, because the Saint-James delivers exactly what its guests want. The hotel has a niche market, catering mainly to CEOs and entertainers. This is the way they wish to live away from home. And beyond all the perks, what they demand most from the St-James is privacy, which everyone

does their best to provide them. Employees have to sign confidentiality agreements to ensure that." Pause. "There is truly nothing like this in Canada, and very little like it anywhere else in the world.

Glimenaki has a point. There are the Georges V and the Plaza Athénée in Paris. And, well, the Saint-James is right up there. Only sixty rooms for guests, but 110 employees to cater to their every whim. Chambermaids do the rooms twice daily. Linens, as well as the attire of guests, are hand-ironed.

Current general manager Robert Vandette cites this pampering of guests as the key to the hotel's burgeoning success. "Apart from the opulence and luxury, it's really all about personalized service. Service is like a religion to our staff."

There is service and then there is service. The ratio of staff to patrons is aslmost 1 to 1, and goes even higher during peak periods like the Grand Prix.

Lucien Remillard, the hotel founder/real-estate magnate/movie mogul, spent three years scouring the planet with renowned designer Jacques Bouchard in search of objets d'art to furnish the place. "Over twenty-five years ago, M. Remillard started his quest to create the ultimate hotel," says Vandette. "He travelled the world, visiting palaces in Italy and châteaux in France. He took the best ideas and then he hooked up with M. Bouchard to turn his dream into reality. M. Remillard didn't want the rooms to have a hotel feel. He wanted guests to feel like they were staying in some rich aunt's château. He wanted them to feel divorced from reality and to have them live in a separate world. That's why this is Montreal's answer to the Grand Hotel"—the fabled super-luxe Berlin hostelry where Greta Garbo "vanted to be alone" in the film that netted the Oscar for best picture of 1932.

Remillard's success in making his vision real explains why the Saint-James's occupancy rate is so high, meaning this hotel flourishes in a market that bubbles over with both boutique and chain hotels, many not flourishing.

"The trick is to have a vision and to choose your staff well. Most of our staff have been with us since Day One," Vandette says. Oh yes, there's one more thing: Vandette acknowledges that having an owner with deep pockets to match his impeccable taste also helps.

"The hotel is old school and majestic yet it is not lacking for any of the modern amenities," explains Glimenaki, whose degree in art history served her well during her tenure here (she has since moved on to another management position in the hotel trade). "This is a grandiose spot where the staff tries to fulfill the guests' every desire, and I think they generally succeed, based on the feedback I've received." That means supplying guests with foie gras and Dom Perignon at four in the morning, or an English high tea in French porcelain at four in the afternoon.

The hotel is "an exquisite marriage between the old and new," states Vandette, adding that the support services operate out of a building across the street which is connected by an underground passageway.

Suffice it to say there is nothing else quite like Le Saint-Jimmy in this town. It could easily stand in as a museum. Even the bloody elevator looks like it was lifted out of the Renaissance.

Mind you, the St. Jimmy—as I feel it should be called, giving it a nice clubby London feel—has survived Madonna and Mick Jagger (more daunting, it handled the renegade Keith Richards). And Jennifer Lopez and her Marc Anthony. And Phil Collins. And Bruce Springsteen and his E-String Band. And Sting. And, according to the lore, Brad and Angelina. And they say that, given his druthers, Tiger Woods would have practised his putting and camped out here during the Presidents Cup at the Royal Montreal Golf Club.

"They are surprisingly gentle men and women," Vandette notes of the various celebrity guests. "Though their image may be wild, there have been no wild scenes in the rooms or bar. No swinging from the chandeliers. Why they love our hotel is because we respect their privacy, and they in turn show great respect to us."

No doubt. And the ornateness of the place is perhaps intimidating enough to make even perennial Rolling Stones bad boy Keef behave like a proper British schoolboy.

The astonishing thing is that the St-James became the in-spot for celebs from the music and movie worlds in a relatively short time—and without advertising. "It shows you the strength of word of mouth," says Vandette.

Mr. Bean has also stayed at this oh-so-stately spot. So much delicate

stuff so prone to breakage, and the bumbling Bean on the scene: could mayhem be far behind? Ah, that scenario was the stuff of fantasy for the anarchist lurking within many of us. Alas, while I conjured up a "Mr. Bean in Montreal" movie in my addled mind on the way to interview the actor, reality set in once I arrived at the hotel. Rowan Atkinson, in town for the 2007 North American premiere of the film *Mr. Bean's Holiday*, turned out to be nothing like his alter ego. I can report that Bean ... er, Atkinson deftly avoided bumping into the Louis XVI coffee table in his suite and sat down on a Victorian-style divan without incident. Damn.

But the 45 minutes I spent with him is as close as I've gotten to staying at the St. Jimmy. The only other option for such as I is the lobby's bar/resto XO—pretty spectacular in itself, with its massive palms and pillars and chandeliers. The decor is of the Art Deco variety—with an abundance of marble and mahogany and leaded windows. If privacy is in order—for business or some subtle smooching—curtains can be drawn around the corner tables, separating the occupants from the rest of the room. There is a majestic staircase leading to a second floor, all the better to spy on those below. Actually, one half expects to see the Great Gatsby come bounding down the stairs.

Then again, perhaps the lobby bar isn't so accessible. Don't know about you, but I've never seen Rémy Martin Louis XIII Grande Champagne sell for $225 a snifter in these parts, or a 1947 Château du Laubade Armagnac shooter for $130. Or an 800th-anniversary shot of Richard the Lion Heart calvados for a relatively modest $55. The single-malt Scotch list is impressive, with an eighteen-year-old Macallan topping the list at $55 for a wee dram.

Martinis, all eleven of them on the list, are thus a steal, with none fetching more than $12. However, if you opt for the Grey Goose vodka, as nearly everyone at Le St. Jimmy seems to do, the martini will set you back $15—but jumbo olives are included, as are a mini-assortment of nuts and chips. On the other hand, you could select one of six champagne cocktails, ranging from $18 to $23. All the better to wash down the $190 plate of fine domestic caviar.

High tea, as advertised, is being happily quaffed by more than one gaggle of matrons, not to mention the odd exec, at 4:14 p.m. And it

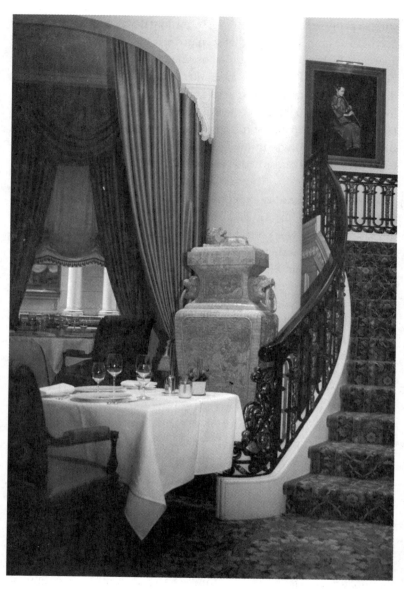

Can you say "lavish"?

doesn't come in tea-bag form, either, as it's served by cretins at other hotels in town. Heavenly smelling tea leaves from the far reaches of the planet are de rigueur here. With, of course, scones, freshly baked in the St. Jimmy kitchen. And Devonshire cream. And cucumber sandwiches. "At $45 for the tea service, it's like a little vacation to England," muses Buffy DuPré, the Montreal socialite who has just dropped in for high tea with a side of bubbly.

"Le Saint-James is the place to come if you want to pretend you're someone other than yourself, someone more important," says Buffy. "Just dress up and act the part."

Nor is Buffy dissuaded by the criticism by some that the bar is "a tad too solitary and stiff." "Nonsense," she retorts, champagne cocktail at hand. "This is now the ultimate in town. Everyone who is anyone and many people who are no one descend upon the place. The Ritz is oh, so 1970s—or some other dreadful era—in comparison. And, surely, one will never run into a Madonna or Mick Jagger or even a Mr. Bean at the Ritz these days."

But if high tea at happy hour—or close to it—ain't your cup of tea, the St. Jimmy has a wine list to rival its alcohol and tea lists. The hotel has 4,000 bottles stored in its cellars. It also has the engaging Elyse Lambert, once voted best sommelier in Quebec and third-best in Canada. And no wine snob is she. Lambert has been known to favour chardonnays from the colonies, like New Zealand. Which is not to say that she isn't fond of the finest wines from France's Bordeaux region, either.

"I love my work and I truly believe I have the best job in the world," Lambert gushes.

I truly believe she does, too, particularly as we sample several New Zealand white wines, then a few French reds, then divine dessert wines from Italy. "The trick in my trade is never try to intimidate people," she explains. "Let them just enjoy and don't overdo all the wine talk. On the other hand, if they do ask, don't be afraid to talk of a wine's buttery quality and its nuttiness. Wine is all about balance, both in its make-up and its presentation. It's one of life's great pleasures and should be treated as such."

Glimenaki echoes those sentiments: "Just because the hotel serves

the finest and has the finest doesn't mean staff have to have attitude.

What hotel management won't stand for here is pretentiousness. Nor will the clients. They want to feel like they're at home— not like they're in some stiff boarding school. People have strange notions about celebrities. But they're no different than most people—once you get over how much money they have," she says. "They dress the same way, they sleep the same way and, believe me, they complain the same way as regular folk."

Glimenaki ceases with the comparisons for a minute. She picks up a linen napkin at the bar and examines it. "It's a random check. I'm making sure there's not too much starch and that it has been perfectly folded. People only notice when there's something wrong, but will never comment if everything is perfect. And that's the way it should be."

Perhaps, but some of us are now really leery of wiping our scone-filled mouths and messing up the most perfectly starched and magnificently folded linen napkins in, quite possibly, the entire universe.

[Hôtel Le Saint-James, 355 St. Jacques Street]

5:00 p.m.

WITH HIS LONG PONYTAIL, beard and full-jeans attire—jacket and pants—Jean de Castell looks every bit the working-class hero. He also looks right at home at Magnan's Tavern, the Point St. Charles institution that has long been home to working-class heroes as well as thirsty sports fans, roast-beef lovers and politicos trying to tap into all the above for votes.

Looks can be deceiving. De Castell is a long-serving Westmount city councillor. Not that he hasn't been a hero to his constituents over the years and not that he inhabits the highest reaches of Westmount— he actually lives in the lowest reaches, on Selby St., across from the train tracks in an area he calls "Upper St. Henri"—but the idea that a Westmount city councillor's favourite haunt is a Point St. Charles tavern is indicative of how times change and how the Point has changed.

What used to be one of the city's more rough-and-tumble neighbourhoods is now surrounded by some of its hippest lofts and condos, populated by some of our hippest artists and professionals, including some who have ponied up more than a million dollars to be in the shadow of Magnan's.

And what used to be one of the most major male bastions in Montreal is now the haunt of almost as many women as men. Magnan's opened its doors to women in 1988, and with that came a few not so subtle changes to the menu, both food and booze-wise. De Castell has been hanging out and knocking back brewskis at Magnan's for more than thirty years. Over the last twenty, though, his beer-drinking buddy has been his spouse Terry Lanthier. It's 5:43, and the couple are polishing off their customary roast beef dinner.

"Actually, I used to sneak Terry in even before women were allowed," de Castell confesses. "We would get some really dirty looks from the other patrons. She didn't care. This is her kind of place, too. Food is great. Beer is cold. And ambience is the best."

De Castell has another admission: Westmount Mayor Karin Marks is also a big fan of the place, as are other Westmount councillors. In fact, Marks and her team are not beyond making policy decisions over a few cold ones in the Point. Curiously, de Castell and the other councillors just might blend in better here than they would on their own turf. "Let's just say we like the downhome atmosphere here. And let's just say that Karin is one of the most down to Earth people around— she doesn't even drive a bloody car. So she fits right into this kind of milieu," de Castell diplomatically states.

It's a reasonably safe bet that when unemployed blue-collar worker Armand Magnan first opened Magnan's Tavern in 1932, he hadn't contemplated catering to Westmounters—even salt-of-the-earth types from that community. His plan was to create a haven for other blue-collar folk hit hard by the Depression and to offer brew and sustenance at reasonable prices. Armand dispensed the beer, while his wife Marie-Ange did the cooking, simple, stick-to-the-ribs fare. And a legend was born.

But times change. With the passing of Armand, his son Yves, a Montreal city councillor, took over the place in the mid-1950s. After Yves had a nasty spat over tavern philosophy with his son Bernard, a physician by trade, and later took ill, Alain Gauthier, who married into the family, emerged as top dog at the beginning of this millennium. Bernard is now out of the business and working as a doctor, while Gauthier is credited with keeping Magnan's on course in the midst of family squabbles, lawsuits and brief labour unrest.

And what was once a small tavern that could seat only seventy has since mushroomed into a monster tavern that can handle close to a thousand customers and serve up to 2,500 meals a day. Calamari, oysters, mussels, lobster, scallops and even salads have been added to the menu, and an array of wines is now on offer.

But make no mistake: beer and roast beef still rule here. Serge Tremblay, a veteran waiter with more than twenty-five years at Magnan's under his belt, estimates that more than 2,500 kilos of roast beef get gobbled up every week. As for the amount of beer sold, Tremblay says he can't count that high. As for tips, he's not saying, but neither is he complaining.

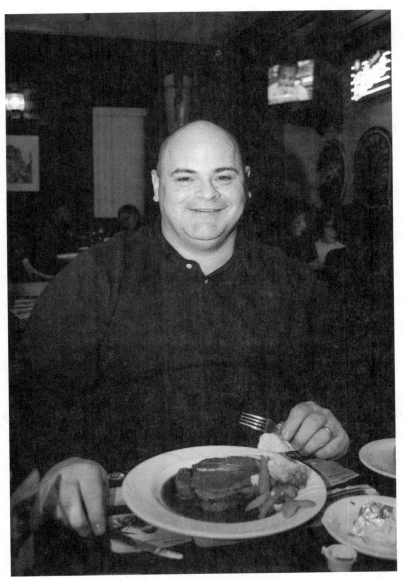

Steve Barette: One Happy Dude about to dig in to a
No. 4 platter of roast beef.

Magnan's may be the only eatery around where the roast beef comes in five different quantities. There is No. 1, the wuss portion: 6 ounces for $14.75; No. 2, the kid portion: 9 ounces for $19.95; No. 3, the teen portion: 12 ounces for $23.95; No. 4, the adult portion: 16 ounces for $29.95; and, sorry ladies, No. 5, the "he-man" portion: 20 ounces for $34.95.

Tremblay estimates that, in spite of changing diets and mores, he still sells dozens of "he-man" portions daily. "Some guys still want to prove they can do it," Tremblay notes. "And so do some women as well."

The table of eight next to mine is typical. Two couples and their four offspring between eighteen and twenty. The two dads order No. 4s. Three of the four offspring order No. 2s. The other opts for a filet mignon. And the two moms go for chicken and seafood.

Steve Barette, one of the two dads, generally goes for a No. 5 and offers an explanation why he's only doing a No. 4. A former member of the Canadian armed forces, he is still a reservist on weekends. "I have to do a thirteen-kilometre march in field attire with full equipment tomorrow," says Barette, built like a boulder. "And I don't want to collapse in the middle of the march."

While Barette, now toiling in the plumbing world, has been a frequent Magnan's patron for twenty-five years, he has decided to introduce his sons Spencer and William to the joys of the tavern this evening. He recommends they each start off with a No. 2—largely because they've also ordered appetizers and had eaten only a few hours before coming here.

Meanwhile, Barette's nephew at the other end of the table, also a first-time visitor, is celebrating his eighteenth birthday on this day, and to mark the occasion will have a No. 2 and his first "officially sanctioned" beer.

Spencer and William Barette feel like they are beginning their ascent into manhood by coming to Magnan's for the first time. ""I've heard about it for years from my father," says Spencer. "I know it can be wild when there is hockey on TV here, but it feels really cozy."

"I've heard so much about the roast beef here," says William. "I hope it lives up to expectations. What I can't get over, though, is the number of giant TVs in this place. There's gotta be a hundred. When

they show games, it must feel like being in the actual Bell Centre."

Papa Steve smiles. The experiment is going well. "This is a rite of passage," he says. "Now that they're old enough, I wanted them to share with me the joy I have in coming here. The food is terrific. And the beer is cold. The service is so friendly. But, best of all, there is no pretension to the place whatsoever. I've been to many taverns and brasseries in my life, but none can top this."

Steve is interrupted by his nephew, swilling his first "official" beer. Seems that the kid's mom, Steve's sister, also a Magnan's first-timer, has ordered chicken wings for her main course. "She comes to the most famous place for roast beef in Montreal and she orders chicken wings? That's blasphemy!" booms Barette, tongue somewhat in cheek. "Seriously, though, I know my beef. I've been to the best roast beef places in Chicago and Calgary, and nothing beats Magnan's."

Barette says that when he was in the army the chef used to pretend he was making his own roast beef for regimental dinners, but he was actually sneaking into Magnan's and buying it en masse. "He tried to pass off Magnan's roast beef as his own, but he couldn't fool us."

Though not initially certain it was a good move, waiter Tremblay now believes the decision to allow women into Magnan's was brilliant. "It has been excellent for business, because we're now getting the wives of our regulars. But, honestly, it hasn't been good for all the male customers, who complained at first. We had to evolve and to change with the times, otherwise we might not have been able to survive."

The roast beef has arrived at the Barette table. Steve's eyes light up. William is first to dig in: "Nice and juicy, dad."

"Wait for the horseradish, son," Steve counsels. "It brings the beef to a whole other level."

"I'm more of a steak-sub kind of guy," Spencer says. "But this is every bit as tasty."

Patriarch Steve simply rolls his eyes, before getting down to the business of devouring his beef. A few bites later, he comes up for air: "This is as good as I remember—and then some."

Meanwhile, my No. 2 arrives. With a side of pepper sauce. Wait. What's that green thing on the plate, I ask Tremblay.

"It's broccoli," he informs me.

What's that?

"A vegetable," he shoots back with a broad smile. "It's supposed to be good for you. Apparently, man can not live on beef and beer alone —especially when their wives are around. Times are changing. And, in fairness, it's not just the women customers who are asking for vegetables and salads with their meals. The same guys glued to the hockey games on TV are also requesting it."

Over at the Barette table, they've all finished their meals. Steve announces he could have done a No. 5 this evening. As a result, he still has room for desert—pecan pie à la mode. Spencer goes for the apple pie, William the sugar pie. "We may be smaller, but we can keep up with our dad," says Spencer.

Steve gets philosophical for a moment. "How many places have survived seventy-five years in this city? It really has to be special to do so. That's why Magnan's is an institution."

Steve's significant other, Gina Camalani, pipes up: "The roast beef is truly excellent here. My family is always asking me why my roast beef isn't as tender as Magnan's. Well, let's just say my roast beef is edible, but this one is far superior. They all seem to like that answer," she says. "Anyway, it all works out in my favour. I get to be taken out to dinner here, instead of slaving over a stove at home." She blows a kiss over to hubby Steve. "It's all good. They're happy. And I'm happy."

[Magnan, 2602 St. Patrick]

6:00 p.m.

WE'RE SMACK IN THE MIDDLE of Holder's fabled 5-à-7. The brash and the beautiful, as is their custom, have descended en masse on this Old Montreal hotspot. Curiously, it formerly housed a stuffy bank but, since opening as a comfy and understatedly chic bar-bistro in 2003, Holder has become one of the most sought-after rendezvous points in town.

It's 6:27. There is not a seat to be found among the 180 at the bar and surrounding tables. And so what if you can't hear a bloody thing in the place? The noise of clinking glasses and loud chatter is a welcome relief, particularly in this part of town where a few decades back the only sounds that could be heard were those made by calèche horses clip-clopping down the cobblestoned streets.

Holder has the look of a finely matured Parisian bistro—a remarkable feat, given its young age. Rich leathers and woods abound. The scene could pass for a movie set. Chalk up another hit for Montreal's famed Brothers Holder.

"We were looking for a place to create a new party," says the diminutive Maurice Holder, twin brother of Richard and younger sibling of Paul, who can barely hear himself in the din. "Our goal was to liven-up Old Montreal, to be part of the new wave reinvigorating the area. Because, if there is an area that deserves to be thriving in the city, it's this one. The city's history is all here."

Not that long ago, much of Old Montreal was up for sale—at wholesale prices. No longer. The young and the restless—those with jobs, anyway—have moved in to the myriad condos and lofts in the area. Add the army of working folk by day, and you have a large contingent of people who need places to mix it up in the evening, thus accounting for the success of Holder and numerous other bar-bistros nearby.

Maurice Holder: Building the city one bistro at a time.

As an added enticement, the bistro fare at Holder is not only divine—particularly for those of us who can't ever get enough oysters, chèvre salads, beef tartare, steak-frites and ... mmmm ... lobster ravioli—but also downright affordable. Toss in a wine list almost as quirky and eclectic and, yes, reasonable as that of L'Express, and you've got the makings of a landmark Montreal destination.

No surprise, then, that Holder, open seven days a week for lunch and dinner, accommodates more than 2,000 patrons a week and ranks among the most profitable restos in town, with, reputedly, L'Express-like annual sales numbers in the lofty $4-million range.

"It's a good thing action here takes place at a relatively early hour, because I can no longer stay up past midnight," cracks Maurice. "I'm pushing fifty and I'm also pushing around a twenty-month-old and a two-month-old kid in carriages."

This is a far cry from the old days when the Holder brothers were not only kings of the Montreal wee-hours party scene but were also among the leading creators of said scene. The Holder brothers are credited with breathing new life into the once-suffocating Main in the mid-1980s. And now with Holder going gangbusters, they have been doing their bit to accomplish the same in Old Montreal. They faced their biggest challenge yet in 2007, and while the final outcome is still uncertain, no one other than the Holder brothers would even have attempted it: to resuscitate one of this city's most venerable restos—Delmo.

The new Delmo, under the Holder umbrella, was temporarily closed in the summer of 2008. But the Holders have vowed that, with new partners, Delmo will again rise triumphantly. Delmo had been down this road before. Nearly $3 million and three years after it had looked like it was lights out for good, la Grande Dame that was Delmo rose from its ashes in 2007. Much of the legendary oyster bar in front remained intact, and aristocratic reds and mahogany ruled elsewhere, giving the spot the same intimacy and charm for which it was once so renowned. Truth be told, before it closed, the old Chez Delmo had been getting a little ragged around the edges and was in desperate need of a facelift, not to mention a few fire escapes. After all, it was only horses that served as transport on the cobblestoned streets of Old

Montreal when the building that housed Delmo was erected in the mid-19th century.

"This was the most complex renovation we've ever undertaken," says Richard Holder, the brother delegated to handle the Delmo file. "Every time we probed, we found something else that needed repair. But because every building in Old Montreal is protected, every move required some kind of municipal approval. Somehow there were no emergency exits in the back, and, frankly, the entire structure looked like it was built out of matchsticks and could have gone up in flames in seconds. There were no sprinklers, either. The original owners must have known the mayor to get away with this." In sprucing up the place, Richard hired architect Jacques Rousseau, a frequent collaborator on Holder brothers projects, to bring the space up to speed decor-wise. "Our philosophy was: Let's preserve the essence of the place. Let's do to Delmo what Volkswagen did to the Beetle, let's bring into the third millennium." For a long time, it looked as if Chez Delmo, an institution in a city often short on enduring institutions, had served its last supper in November 2004.

A deal to sell the three-storey building to a real-estate developer had fallen through, so Roland Perisset, the charismatic seventy-six-year-old owner (now deceased), simply closed the doors of the legendary establishment. There were shockwaves in town. Few restaurants had captured the soul of this city the way Chez Delmo had. In fact, so fervent were its devotees that they were referred to as Delmonians. Even though the sphere of corporate influence had shifted from Montreal to Toronto since Perisset took over the place in 1964, Chez Delmo continued to be a magnet for power brokers from far and wide. Captains of industry, politicians, judges, lawyers, bankers and entertainers religiously descended on it. Romances had been kindled and rekindled there, and milestones had been celebrated.

While the restaurant was steeped in class and tradition, Perisset liked to regale listeners with naughty tales of the edifice's early life. According to him, a private men's club was opened there in 1908. To be more accurate, it was a high-end drinking establishment on the first floor, a gambling parlour on the second floor and a bordello on the third floor. With the Depression in 1929, however, this gentleman's

fantasy world came crashing down. In 1934, the place became the respectable Delmo eatery. And when Perisset took it over in 1964, he named it Chez Delmo.

Whatever happens with Delmo, it's been quite the wild ride for the Holder brothers. They first popped up on the cityscape back in 1982. Their first effort was the east-end bar, Braque, conceived by the afore-mentioned avant-garde architect Rousseau as well as Serge Breton and the brothers.

Richard was all of twenty-two at the time, and recalls their ascent on the scene:

"We created Braque in a vacant lot, and it was immediately a hit. It's like we were instant stars in some circles. It was a little bizarre." Not content to merely allow patrons to bop to the beat of the latest in techno-pop, management also felt compelled to change the decor every couple of months to avoid undue ennui. Highlights included a plethora of television sets placed at the oddest angles, fluorescent blue showroom dummies with missing limbs, and the outrageous, multicoloured "fast-food frescoes" of graffiti artist Zilon.

The brothers sold the spot three years later, and put their efforts into the one that would put them forever on the map, nightclub sector. The club: Bar Business, deemed the town's numero uno club among aficionados of what's hip and hot and what's not. Business—those in the know quickly dropped the "Bar"—was located on the ground floor of the refurbished Reitman's building on the Main at Milton Street, and was clearly not meant for the fern-and-formica set. Bolstered by a $500,000 investment, Business had a high-tech yet fashionably seedy sort of industrial ambience—exposed pipes, jagged concrete slabs, a trough with running water extending along the bar.

And Alain Lortie, the award-winning lighting consultant of per-formance artist Michel Lemieux, unveiled his aptly titled "Power" extravaganza, starring more than 200,000 watts of mind-numbing light in every colour known to man and then some.

And so the transformation of the Main had begun.

Richard Holder remembers how it all started. "Maurice, Paul and I were sitting on the porch of my parents' place in Quebec City, and we thought it would be cool to open a bar. Of course, we had no idea what

it entailed back then. If we had known then what we know now, who knows? But our parents were very supportive." Interesting family history. Their dad was a British Royal Air Force pilot dispatched to Quebec City for a stint during the Second World War. The night he arrived, he met a beguiling Québécoise. They married shortly thereafter and have been together well over sixty years.

Richard also remembers that when he and his brothers started making noise in the mid-1980s, many had given the nightlife on the Main, and in the city in general, up for dead. "There really wasn't much going on at the time, so we felt there really wasn't much to lose. We had an idea of what might work, but if there was a surefire formula for success, I'd probably be on a yacht in the Caribbean now." Maybe there was no formula. But the brothers also knew there were no-nos to avoid. "Many of the clubs in those days had their dance floors in the back—which is so wrong. Dancers are exhibitionists and the people watching them are voyeurs. Therefore the action should take place on dance floors in the middle of the club," Richard explains.

And thus Business became the place to be—if you could get in. "It was funny, because we didn't come from a socially connected family. I recall thinking in the early days of Business that it was a good thing I had the keys to the place, because otherwise they would never have let me in. There really was such a ruthless policy at the door: if you weren[1]t hip or beautiful enough, you didn't get in." But like all hip and happening things, Business ran its course. "People would come five nights a week, but they eventually ran out of steam," Richard says. Likely money, too. So the brothers let go of the lease there and concentrated on Le Swimming, to the north on the Main. And no sooner was it launched in 1990 then it was deemed the city's hippest club.

"It was basically a trendy pool hall," Richard recollects. "Maurice and I would look at each other and be puzzled and stunned that young hipsters would line up to come here and play pool." After fifteen years, they became bored with Le Swimming and sold it. Next, they switched course and moved into the volatile resto trade. "What we learned very quickly in the game is that even the most successful bar rarely has a shelf-life of more than five years, but a restaurant, if done well, can endure for decades," Maurice notes.

Their first effort, Brasserie Holder, on the Main, attracted enthusiastic customers, primarily because it offered a recession-beating table d'hôte for $9.95. "We're entrepreneurs. We didn't read the book on restaurants. But we learned in a hurry," Richard says.

Though the latter brasserie is history, the brothers learned well. In addition to the Old Montreal bar-resto Holder, their follow-up to Brasserie Holder, the brothers also run the downtown Café du Nouveau Monde in the Théâtre du Nouveau Monde building across the street from Place des Arts. "No question, we're living on the edge," Richard adds. "But we've never lived anywhere else." "What we have learned is that Montrealers love their bar-bistros," adds Maurice. "But they like them without pretensions. We can't stomach pretentiousness, either, so we can certainly understand." Like his twin bro, Richard has also long eschewed the wild nightlife of his past. "My number one concern now is my son Dylan. He takes precedence over everything," states the single dad. He does point out, though, that the club scene has dramatically changed. "Now it's the whole rave warehouse thing that's in vogue. Business was one of the last places people went to as a destination place. Now people go to events, not so much to destinations. It would really be a challenge for us today to come up with a winning club concept." Nor is he a big fan of the St. Laurent Boulevard scene he helped create.

"There's a sameness to many of the places on the Main. Might as well stay at home and stand in front of the mirror to get the same feeling. We used to have meetings when we started Business, where we¹d say that the club must have three rules for survival: that it be urban, industrial and theatrical.

"We would tell our staff that we weren't selling beer, we were selling an experience. Why else could we charge $4.50 for a beer that people could buy for a buck at the dépanneur?" As for the future, it's simple: "We plan to take over the world and sort everything out," Richard deadpans. "Actually, we have made a conscious decision not to fire off in every direction, although I'd love to start a hotel. The ice-hotel concept has been done. I'm thinking maybe a treehouse hotel—with forts and everything. Seriously. In Kenya, they opened a posh hotel in a treetop." And then there's Richard¹s idea for a festival in town. "I know there are

just so many—so Festival Holder would go where the others haven't. No question, Montreal would be the perfect setting for a ... sex festival.

"Can't believe no one's come up with it before. People would love to nibble on that kind of festival." (Pun apparently intended.) Maurice, on the other hand, is not so certain about heading off in that direction. "We¹ve slowed down a lot over the years, but we hardly lead what I would call peaceful lives at present. We still have plenty of stress in our lives. Of course, that comes with the turf," he says, pausing for a sip of his Pinot Noir at the Holder bar. "But if you do grand projects like we try to do, you're going to have your share of ups and downs. And we have. There are days when we feel so confident about moving forward. But there are other days when we only remember our screw-ups and feel that we're only as good as our last project. But hopefully we have proved to people that we're not quitters, that we will hang in at all costs and that we love our city." No doubt about it.

"What I love most about Montreal is that it really is so tolerant at the core," Richard adds. "We live and we let live. Yet if Montrealers are relatively not so well off financially, we are still able to compensate for that with our joie de vivre. Maybe that's really why we have all survived."

[Holder, 407 McGill Street]

7:00 p.m.

WOMEN HAVE MADE MAJOR STRIDES in just about every facet of Western life, but not, ironically, in the kitchen. The restaurant kitchen, that is. You could count on the fingers of one hand the number of female head chefs at top-rung Montreal restaurants. And even that might be overly generous. Helena Loureiro is abundantly aware of this inequity.

Don't let the easy smile and laid-back public demeanour fool you: Loureiro is as tough as they come in a chef's smock. She has had to be. Co-owner and principal chef of Portus Calle, a little treasure of a seafood and Portuguese resto on the Main, Loureiro has paid her dues in the trade, and they are now paying huge dividends.

Portus Calle is a magnet for franco, anglo and allophone artists, broadcasters and professionals. It has never had to advertise, because since the restaurant's opening in 2003, word of mouth almost immediately ensured full houses. In the midst of the chaos of road and sidewalk construction on St. Laurent Boulevard in 2007, numerous businesses on the stretch, including restaurants, went under. Astonishingly, activity at Portus Calle actually picked up, despite the fact parking was nonexistent and the sidewalks outside were barricaded to the point that would-be diners had to consider hurdling them. But such are the lengths die-hard foodies in the city will go to feast somewhere they deem divine.

Loureiro has no explanation, other than to remark that Portus Calle has obviously emerged as a destination point, along with Schwartz's and Moishe's nearby, where faithful customers will brave snow and sleet and rain and barricades to have a nibble. It's 7:37, and there is nary a table to be had, neither in the restaurant's main room, which holds about a hundred diners, nor in the bar area in the back, which can accommodate close to thirty. Regulars have a habit of arriving after nine and staying until the wee hours.

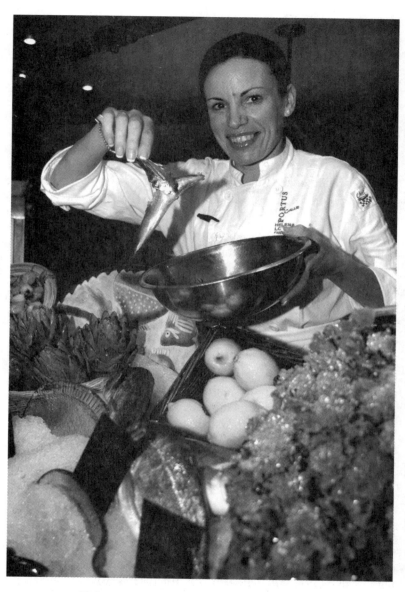

Helena Loureiro making it on her own terms.

After having set the evening's menu, then having neatly placed the seafood catches of the day in an ice-filled display case, then having conferred with her sous-chefs, waiters and two co-owners, Loureiro has come up—briefly—for air. Despite the pressures of the job, she is, at forty, still very youthful-looking. "What keeps me on my toes is that I know I can never ease up," the slender chef says as she ties her shoulder-length red locks back into a ponytail. "This is a métier for men. It always has been, and it probably always will be. Women have to be twice as good to survive, and the pressure is on all the time. One has to have such passion to survive in this métier—which I have." Pause. "And one has to be a little bit wicked, too. And that I am." She flashes a knowing wink.

Loureiro was born near Fatima in Portugal. From the time she was nine, she knew her destiny was to become a chef. That's when she started working in the restaurant of a relative. A few years later, she studied in the field. By the time she was fifteen, she became chef at her aunt's restaurant in Portugal.

"It's one thing to be a chef, but it's another to be a restaurant administrator," says Loureiro, who moved to Montreal when she was twenty to pursue her culinary studies and her career. "You have to be proficient in both to run a restaurant. You have to be tough—very tough; like an octopus—to make it. My father is tough. I'm tough. And my two sons, Daniel and Diego, are becoming tough. Because without strength of character, it's nearly impossible to survive at anything in this world."

Her sons, both attending school, put in regular stints as busboys at Portus Calle. "It's very important for them to know what I do and to see my world away from home."

And her husband? "We've never worked together. It's dangerous to mix work with marriage." Her husband, she notes with a sheepish shrug, works for Kraft, in the cheese department. But rest assured, her customers will never find any of her hubby's product on her cheese plates—which tend to feature exotica from Portugal.

Loureiro allows that she gets along better with men than women. "Women tend not to trust other women, especially those with great ambition. Men have always liked me better."

Which is certainly the case with her two affable co-owners, David Barros and Dinis Seara. The trio first hooked up at another Portuguese resto, Tosca, where they all worked for a spell. They decided they could make a go of it themselves in the ever-turbulent Montreal restaurant world.

"Good thing we were a little naive, because if we had known then what we know now, we would never have undertaken such a project," explains Barros, thirty-two, one of the most gracious maître d's in town. "But at least we knew that if we stuck to what we do best, Portuguese food and seafood, we would have a better than average chance of making it. Especially with Helena as chef. She knows food as well as anyone I've ever met. She is so good that her kids prefer to eat sardines and salads over hot dogs and hamburgers. In fact, I don't think either of her kids has ever even had a hot dog in their lives."

Portus Calle, incidentally, signifies Portugal. "And it's traditional Portuguese cuisine with a modern twist that has enabled us to stand out," says Barros.

He was born in Montreal but comes from solid restaurant roots. His dad was a bartender/waiter at the legendary Bodega on Park Ave. And he's been working in the trade as long as he can remember. "It's about the food and it's about the service," he explains. It's also about the price. It has oft been noted that while Portus Calle's fish is on a par with the likes of the famed Milos, its prices are about half as much.

"What makes us feel most proud is that we were selected one of the three hundred best tables in all of Quebec—without any advertising whatsoever," Barros says. "And business has doubled every year since opening. Our clientele is very loyal. And they obviously talk a lot and tell others to come."

Loureiro says success is no accident. "The secret is details, details, details—in the food, the preparation, the wine, the service, the prices, the decor, the plates. Everything must work. And every day for me is like the first day, where you have to prove yourself all over again."

To that end, she attends food shows, dégustations, wine tastings and seminars wherever and whenever time permits—which it doesn't often do. She rises at seven in the morning, every day but Sunday when Portus Calle is closed. She goes to Marché Central and the Jean Talon

Market in search of provisions. At ten a.m., she's in the restaurant, with her newly-acquired fish and veggies. Then it's planning and preparing for lunch. After which, it's planning and preparing for dinner. After which, it's the late-night post-mortem with her two partners. She figures she's lucky if she gets to bed before four in the morning. Which works out to three hours of sleep a night.

"I don't need much sleep. My mind is always working and thinking new ideas," she says.

And what of spending quality time with her hubby? "I don't get to see him a lot, but I feel his presence in bed," she muses.

No surprise that she was also responsible for Portus Calle's cheery, colourful decor, heavy on oranges and yellows. "You need that kind of sunny look to complement the olives and cheeses and wines of Portugal," she points out.

But Loureiro is not merely content running one resto. "The dream is to start another, maybe a little place with a hotel," she says. "Also, it would be nice to have our own vineyard in the Douro region of Portugal. David and Dinis will follow me. We have a marriage together, too. We don't fight, because they know I will always win." She's not just crackin' wise here.

Barros is a little more diplomatic. "I was taught never to fight with a woman."

"And we don't have to fight," Loureiro shoots back. "Because my ideas are always the best—until they can be proven otherwise. The trick in a restaurant is to be familiar with all aspects of it. Everyone is replaceable, but someone has to be in control."

And guess who that someone is here? "And why not? I have never been scared of anyone or anything in my life," she declares.

"We don't have to fight, because we're always in balance," pipes in partner Seara, on a break from tending bar. "We're always respectful of one another."

"The trick is never to go to bed mad," says Loureiro. "We're really very transparent. We get everything off our chests immediately. When I don't like something, everyone knows."

No verbal comment is needed from the two guys. Their spontaneous nods say it all.

"We're not scared—too much—to voice our opinions," adds a grinning Seara.

"That's right," says Loureiro. "I always say what I want, so there is no negativity in the air. I practise what I preach, which helps, too."

Loureiro acknowledges that it's highly unlikely she could have made the gender breakthrough in the kitchen anywhere but here. "I used to ask myself what brought me here in the first place," she laughs. "Sometimes I still ask myself that question, particularly when the snow comes. But it's been such a great adventure here. Montreal is the most spectacular city in the world. It's also one of the most liberal cities in the world. It's all here. A woman can do it all. I have been accepted in spite of being a woman in a man's world. No one has ever mocked me. I feel at home here. I adore Portugal, but I would never change my life here to return there. The only thing I would change, maybe, is the winter. And perhaps the ocean. But I have a good imagination, and when I look out the window here, I don't see St. Laurent —I see the ocean." (Now, that's some imagination!)

Barros feels his fellow Portuguese have adapted well here. Must be true, as there are more than 50,000 Montrealers of Portuguese descent. "Café Ferrera first brought Portuguese haute cuisine to the city," he says. "We're just following that tradition."

"But the sky is the limit," Loureiro interjects. "The day that you believe you've reached the top— that's the day that you're finished. One can never be complacent in life. There's always someone coming from behind, ready to take over. Knowing that is what makes women so tough. Men may try, but they can't stop us. I may be one of the few women chefs around, but I promise you that situation will change dramatically in the years to come."

No more time for table talk. Loureiro is called upon to do some magic with the fish and tapas in the open kitchen area. "I eat well," she says. "But I'm too active to accumulate any weight. I'll never be able to slow down, either. I'll probably die standing up—like a tree—but smiling."

And still uttering "Obrigado"—you're welcome—to the stream of ever-grateful customers.

[Portus Calle, 4281 St. Laurent Boulevard]

8:00 p.m.

IT'S COLD AND WINDY and wet, a precursor of the winter nastiness TO come. Slipping along St. Jacques Street in St. Henri and seeking immediate escape, we hear a voice call out to us. Nah, not from above. Don't be confusing this with some Jimmy Stewart religious allegory. Someone is belting the blues inside what is, from the outside, a fairly nondescript shop.

We take the bait. We enter. And—whoa!—we're in a time warp. Think Greenwich Village, circa 1964. It's actually 2007, 8:34 p.m. Details, details. The place is called Pages, a second-hand bookstore cum coffeehouse. Books everywhere. Chess sets. Comfy chairs and sofas. Warm primary colours—oranges, reds and yellows—rule. On a guitar case in the corner, a sticker seems to sum up the place perfectly: "When the power of love overcomes the love of power, the world will know peace." Okay, maybe no hooch is called for on the heels of this sobering message, but cappuccino will work on this night. And every other night. Pages is not licensed for liquor.

Talk about '60s atmospherics. At any moment, we expect a young Bobby Zimmerman—Dylan—to saunter in with a young Joan Baez in tow. They, too, would likely be blown away by chanteuse/keyboardist Katie Sevigny. An intriguing cross between Joni Mitchell and Rickie Lee Jones, Sevigny is singing her heart out. Mostly her own compositions. One is dedicated to her hero, Billy Corgan of Smashing Pumpkins fame; another to Laura Nyro.

"Time for a break?" Sevigny asks her audience. "No, no, go the whole night," one woman blurts. "You're so in the zone—can't stop now," hollers a young fellow. Sevigny obliges. Her sis Jessie, an aspiring thesp, offers heartfelt back-up vocals on the Christina Aguilera tune Walk Away. Then it's a solo version of Sevigny's poignant Blue Covers. Then it's the moving Oh Eddie, which she dedicates to her mom at the back of the room.

Her range is exquisite; her stage presence, stunning. She absolutely radiates. The audience is rapt. And all for three bucks: this has to be the entertainment steal of the millennium.

The kid is going to be a star. The kid also happens to have a day job at the dépanneur next door, where she mostly makes sandwiches for takeout. This is the stuff of which dreams are made. The kid also happens not be a kid. In her jeans and sneakers and sporting her pixie coif, she may look sixteen, but she is actually twenty-six..

When she finally does end the set, Sevigny reveals that she's been singing and playing the last eight years. She doesn't have an agent or manager. She doesn't have any impending record deal—yet. So, in the interim, she will continue making sandwiches at the dépanneur next door. And she will continue writing more songs—she has seventy-five already in her repertoire.

"All I can do is sing wherever I can. Hopefully I'll get the ear of a producer who's ready to take a chance on me," says a no-nonsense Sevigny. "I have no illusions. This is a tough business. And there are lots of great singers out there."

Sevigny is aware the business can be brutal. Her dad, Lloyd Sevigny, known in his day as the Canadian Elvis, saw the ups and downs. His group Lloyd and the Escorts was once all the rage but drifted into obscurity faster than you can say Tiny "Tip-Toe Through the Tulips" Tim. "Again, I totally understand the nature of this beast," a sombre Sevigny says. "It can destroy you. It has destroyed so many."

Perhaps, but, as one spectator tells her, Sevigny beats all to heck anyone ever heard on *Canadian Idol*. Sevigny smiles.

Also smiling is Pages manager Whitney Ellie. The place is as packed as it can be. "The seating capacity here is as many seats as I can find," she jokes. She found at least two dozen. Other guests find standing room where they can.

Since its opening in the summer of 2007, Pages has served as a sort of cultural hub in St. Henri. In addition to stocking close to 10,000 second-hand books—in all manner of subjects in English and in French—Pages also provides a showcase for local writers and performers in the evenings.

Unfortunately, Tim O'Melia, the owner and founder of Pages, can

Katie Sevigny sings her heart out in a second-hand bookstore—it's a start!

rarely take in the nighttime events. That's because when not running the bookstore six days a week, he works as a bartender five nights a week at the Old Dublin Pub to cover the cost of operating a bookstore/coffeehouse.

Before O'Melia opened Pages in this spot, it was a shop specializing in Goth goods and attire—not necessarily a growth enterprise in St. Henri. O'Melia also discovered the locale was residentially zoned, so he had to spend a considerable amount of time to get the zoning changed. Then he combed through the trash of his friends and others for furniture. Then he stripped the aforementioned and restored it.

"I was basically flying by the seat of my pants," concedes O'Melia, thirty-three, a native of Burlington, Ont. who fled to these parts eight years ago. "To be honest, it had never really been a dream of mine to own a bookstore. I was just trying to find something that would enable me to integrate my lifestyle with my work."

O'Melia notes he never went to university, but he's getting an education now. "I've spent my working life bouncing around from construction jobs to bartending to a stint as an assistant to a stockbroker. I've done a lot. Now people are telling me that I've helped to instill a love of literature in St. Henri. I never saw that one coming, but I'll take it."

The area around Pages has changed dramatically over the last few years. There's the headquarters for Muse Entertainment. Can't forget Joe's Café, the eatery of choice in this 'hood. And there's the uber-cool Parisian Laundry gallery, also one of the neighbourhood's best-kept secrets. And owner Nick Tedeschi's philanthropy to the arts may have also been one of Montreal's best-kept secrets. No longer.

Not even Tedeschi's wife Dale knew until minutes before the deed was done a few years back that he was donating one million dollars to Concordia University's Fine Arts department to benefit master's students in the program. "I was worried she was going to tell me that I had lost my mind, that there were other things I could do with my life savings, but she was totally behind the donation," says the soft-spoken Tedeschi. "It was mostly everyone else who thought I was nuts to do this, but I've never in my life felt better about doing something."

Tedeschi, fifty-eight, is not an artist. He simply appreciates the arts and feels that too little funding is available to those who want to pursue

careers in the field. "Grants and scholarships are almost always directed toward medicine, business, science or engineering, but to me the arts are every bit as important a discipline. Art is what drives us, what makes us dream and what defines us, yet there are so few financial incentives for art students. I just want master's students not to have to worry about covering the cost of their tuition and supplies, but simply to concentrate on creating their art."

Tedeschi immigrated to Montreal with his family from their native Italy when he was four years old. His early years, first in Little Italy and then in St. Léonard, were hardly filled with frills. His dad was a manual labourer for Canadian Pacific Railway. His mom worked as a seamstress in a garment factory. "My parents were always supportive and taught me a few invaluable lessons: never get too attached to money, and nothing beats giving to others who are in more need."

After graduating from Dawson College, Tedeschi decided if he couldn't pursue courses at university to become an architect, he would do the next best thing: get into the construction trade and allow architects to achieve their dreams. His construction company has since blossomed big time and is responsible for building, among other edifices, stores for Gap, Banana Republic, Aldo, Le Château, Puma and Apple around the world. Rather than pamper himself with all manner of possessions, Tedeschi poured his profits into renovating the landmark Parisian Laundry, which until its closing in 2001 had been the linens and uniforms washer for many Montreal hotels and restaurants for seventy years. Almost two million dollars in renovation costs later, the Parisian Laundry, at 15,000 square feet, is among the largest and funkiest art spaces in the country.

Tedeschi's wish, though, was not to build a monument to himself but rather to showcase the work of Canadian artists, many of whom couldn't get exposure elsewhere. "There are so many talented artists in this country, but the odds are so against them ever making it into galleries and museums," he says. "I'm no saint. I just happen to love art and have the opportunity to do something about it and give something to this community. Hopefully, others will feel the same way and do something about it, too."

O'Melia admires Tedeschi's dedication and has pledged to continue

nurturing culture at Pages as well. He would like to see unheralded writers, performers and singers—like Sevigny—have a place to launch their careers.

To ensure their survival, he needs to make it, too. To that end, it's not just the books that are for sale at Pages. The chairs, furniture, chess sets, the massive biplane model hanging from the ceiling, all can be had for a price. Even O'Melia's fisherman's sweater, hand-knit by his grandma. "I'm quite attached to it, but make me an offer, and we'll see," he cracks.

Meanwhile, Sevigny is called back by her new fans to do an encore. Her voice intoxicates all again. And, suddenly, the looming onset of winter doesn't seem nearly as painful as it did just a few hours earlier.

[Pages, 3255 St. Jacques Street W.]

9:00 p.m.

DAVID MCMILLAN HATES Saturday nights. "That's when the bridge and tunnel crowd descends upon the restaurant and drinks a lot of Coke," he explains. Fortunately, this is a Friday night, and instead of folks from the 'burbs, there's a largely urbanite crowd that drinks a lot of wine.

McMillan is an artist in every sense of the word. Often, he is an angry artist. Which makes him endearing to many and not so much to others. He could care less. McMillan is in the enviable position of calling his own shots. With partners Frédéric Morin and Allison Cunningham, he runs the city's coolest resto, Joe Beef, and in so doing has helped turn one of the city's most overlooked areas, Little Burgundy, into a suddenly happening spot. All the more so because the same team has since opened the Italian-ish Liverpool House and the wine-bar McKiernan on either side of Joe Beef on Notre Dame Street.

Joe Beef is so intentionally minimalist and downhome and un-trendy that it has become the ultimate in cool. A big blackboard on the wall in the middle of the restaurant displays the menu and choices of wine. But the bar in the corner, a long slab of aged pine, is the epicentre of the place. Bizarre tchotchkes adorn the walls and complement the art of Peter Hoffer, McMillan's pal-cum-frequent customer.

Joe Beef seats twenty-five and offers only two sittings, Tuesday to Saturday nights. Reservations for a table must be made weeks in advance. But a lucky few artists and friends and regulars can occasionally score within a day one of the five bar stools, for dinner and a shmooze with McMillan. The Beef has so much sizzle that apparently even super-chef Anthony Bourdain had to book a week in advance.

Though he has shed much of his former body weight, McMillan is still large and larger than life. In a city chock-full of legendary chefs, he made his mark before he hit thirty. He cooked at Globe and Rosalie's

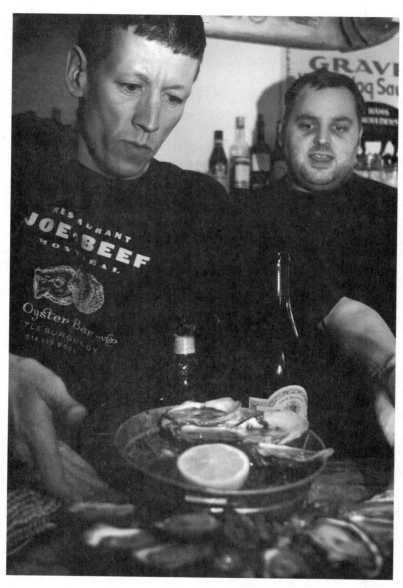

Shucking with John Bil and David McMillan at Joe Beef.

when they were all the rage. But the experience often left him raging. The demands were excruciating. The days were never-ending. He wanted a life. He wanted to return to his other passion: painting. He wanted to slow down. Partners Morin and Cunningham persuaded him he could do all that with Joe Beef.

Joe Beef is named for the nineteenth-century working-class hero who was proprietor of a tavern in Old Montreal. Joe Beef's real name was Charles McKiernan (hence the name of the wine-bar), and he was a true wild man and city original. Much like McMillan. Rife were the tales that McKiernan kept the skeletons of poorly-behaved clients behind the bar and that he kept wild bears and boars in his basement and liquored them up when the mood struck. Yet McKiernan had a softer, less advertised side and would scour the streets of the city, especially in the midst of winter, and offer the homeless food and shelter in return for a little work.

McMillan, thirty-seven, has no trouble relating to McKiernan. He will feed those in dire straits for nothing. He will also turf out the high and mighty no matter how much cash they have. McMillan is mercurial and not remotely repentant about it.

He lives far from the occasionally maddening city crowd, on the West Island with his wife and young daughter. And, given his choice, he would sooner kick back with them on a Saturday night than make small talk at Joe Beef.

Regardless, McMillan, whether he's there or not, can't stop the tsunami wave of popularity that has hit the place. In just a few years, Joe Beef, despite its bovine-ish name, has become the city's premier oyster bar. McMillan had the foresight to conscript an old buddy, John Bil, a Prince Edward Island native who is a three-time Canadian and two-time North American shucking champ. Bil's best-ever performance was cracking open twenty-five bivalves in a blistering sixty seconds. In a decent week, he'll shuck 4,000 oysters behind the Joe Beef bar, all the while mixing cocktails and carrying on conversations ranging from moose to Malpèque mollusks.

Bil has become something of a Johnny Oyster-seed, in spreading the word on the joys of the juicy delight. "Oysters could be the perfect food," contends the buff Bil, also a marathon runner. "They have all the

right minerals. They are low in fat and cholesterol. And I've heard they minimize the effects of a hangover." We're guessing he's more than heard.

And what of the myths associated with the oyster? "You mean the one that oysters are best during the 'R' months? Not true. With strides made in shipping and packaging, oysters are now great year-round," he retorts.

No, not that one—the aphrodisiac myth. "No myth," he shoots back. "Let's just say I've never had any complaints."

Jerry Boland—J-Marv to his buddies—has no doubts that Bil speaks the truth. It's 9:14 p.m., and J-Marv, one of the bar regulars and thus a member of the Joe Beef inner sanctum, hails from the deep South of the U.S. but has found a spiritual home here. A veepee of marketing and sales for CN Rail, J-Marv has met his match in train-lovers: Morin, McMillan's partner. "It was love at first sight—and smell," J-Marv says in his deep drawl. "Fred smelled the train-diesel fumes on me and we've been buddies ever since." This explains the presence of conductor's caps and mini-cabooses and whistles and other train paraphernalia dotting the bar.

No time to talk trains now. J-Marv and John Bil break out into an impromptu rendering of Roger Miller's King of the Road. Another regular, Huge Galdones, is too busy devouring his foie gras to join in for the chorus. He ain't called Huge for nothing. The moniker is a reflection of his girth—"Asian standard, that is," he chimes.

Small wonder that Huge has also gravitated into the Beef inner sanctum. He is a McMillan-esque character. Huge is a photographer and a foodie who writes a blog on city restaurants. And, oh yeah, he is an Ultimate Fighter and trains others in this form of combat. The ever-present smile belies the fact that Huge could, say, yank your intestines out through your ears and cripple you in a thousand creative ways. "Really, I'm just a gentle giant," he says in an effort to reassure. "I honestly prefer eating to fighting." Which suits everyone at the bar just fine. "I like to think of myself as an artist, not a brawler."

"Why do I love this place?" Huge asks. "Not only is the food the best around, but where else are you going to get conversations like these? One minute, we're talking terrines. Next minute, we're talking

exotic dance. I could come here every night of the week—if my finances allowed. And that's saying something, considering that Montreal is a foodie paradise."

"Can't disagree with you there," says J-Marv. "Friendly faces here. Broad range of food, too. Interesting proprietors—real interesting."

Joe Beef is a homage to another era—and to this one as well. McMillan and Co. have the formula. Food counts, for sure. But it's that old ambience thing. You have it or you don't. But you just can't manufacture it.

As he's about to dig into a mammoth plate of roast beef and Yorkshire pudding, Huge points out the grizzly-bear head mounted on a plaque over the bar. "Never noticed it before, but he's got an antler stuck in his teeth," he says. "Maybe that's why he looks so angry."

Huge then casts a glance over at McMillan. Perhaps to check if he's got an antler stuck in his teeth. Not tonight. McMillan is in mellow mode this evening. And he's not drinking. Hasn't been for a while, not since his doctor read him the cholesterol/blood-pressure/liver riot act. And, get this, he's going to the gym. "Okay, don't mention that," he implores. "People want me to be the out-of-control drunk."

So where did it all begin?

"I started off my career where every great chefs starts out: the dish-pit," he blurts, while refastening his apron. He washed dishes, before graduating to salads and sauces and soufflés and you name it. He took cooking classes. He hightailed it to France's Burgundy region for an apprenticeship for a few years. Then he came back to Montreal, where he toiled at the long-running Le Caveau resto. He returned to France for a stint in Dijon. And all this before he was twenty.

Then he came home again to work as chef at Le Gourmand on the West Island, followed by a gig at the Hôtel Vogue, which, frankly, he didn't like. "Actually, I hated it." McMillan is nothing if not blunt. "Food will never be good in a hotel. It's nearly impossible to pull off."

But food was always good in kitchens presided over by late/great super-chef Nicolas Jongleux, founder of Les Caprices de Nicolas and then Jongleux Café. McMillan credits his stint under Jongleux at Les Caprices with opening his eyes to the true wonders of food and the joys of experimentation. After a brief stay in Vancouver, McMillan made

the move to Montreal's trendy Main, where he was declared a boy wonder at Globe. Then he had an offer he couldn't refuse: to become the chef/co-owner of Rosalie.

McMillan had just turned thirty and had become the flavour of the decade in town. But at Rosalie the pressure got to be too much. So did the temptations. "I was completely, utterly burned out. I wanted out," he says. "Then Fred and Allison talked me into semi-retirement here at Joe Beef. It's worked out fine so far. Fred does the cooking. Allison does the books. And Dave does the wine and the talk and the art."

So how did Joe Beef become a haven for the hip when the owner is so blasé? "It's because I really don't give a shit if people like me or the restaurant. Weird, uh? And I don't play by the rules.

"But who really wants to work in a restaurant where the staff is all white, is dressed in white, is eating white, is drinking white—and by that I don't mean white wine. Something is very wrong in a place like that. Fact is, fads don't work. And restaurant fads never work for the long haul."

It may even help that he's a curmudgeon—"Yes, but fashionably so," he kids. "Really, though, when I'm nice to people, they're mean to me. But when I'm mean, they melt in my hands. So, that's the way it is. Yet when I go out to someone else's restaurant, I am quiet and act properly—even if the food has sucked, I'm nice. Amazing, but outside of my job here, I'm really quite polite and soft-spoken. When I'm out with my wife, I talk about our daughter, not about food. The last thing I want is to have the next up-and-coming eighteen-year-old chef serving me his special recipe for scallops and foie gras that I don't want."

On occasion, McMillan feels that he's in the midst of a dream—actually a nightmare. "Then I wake up to discover that the restaurant will be empty and that the joke will be on me. For a minute, I freak out. Then I say: 'Fuck it!' And all is good again."

Leaving the Main and downtown to flee a social scene that he felt was threatening to gobble him up is just one of the reasons "all is good" these days. His priorities have changed. His family comes first. He dotes on his four-year-old daughter, Dylan McMillan (he calls her by her full name, because he loves the rhyme scheme), ferrying her to and from daycare daily. With wife Julie, they lead an almost-blissful

existence in Dorval and, when time permits, in a country home in Kamouraska.

And McMillan has cleaned up his act—since the previously noted frightening warning from his physician. He has shed eighty-five pounds and has another forty to go to get down to 200—although, at 6 feet 3 inches tall, he remains imposing. He not only exercises religiously and exhibits prudence around the plate, but, as also mentioned above, he has virtually given up drinking—a hardship for someone with his fondness for the grape.

Another major shift is that these days, he not only speaks his mind but also expresses it on canvas. McMillan, whose roots are in Quebec City, has been painting for fourteen years, but only seriously for the last four. He has a studio not far from Joe Beef.

The new emphasis on his art dovetails with his altered lifestyle. "Honestly, it had been getting to the point where I was feeling no creative satisfaction in cooking," he says. "Maybe once a month, for about five minutes, when I would help plan the menu, it would get stimulating. But I've long since stopped reading about the restaurant industry and what's hot and who's hot. And, frankly, when I wake up in the morning, it almost deranges me to be thought of as David McMillan, restaurateur.

"It's never been about the money, not when I'm in the business with two partners in a place that seats twenty-five and is open only five nights a week. I love Joe Beef, but I see it as more like an art installation, like an exercise in set design. I don't really cook any more. It's (partner) Fred (Morin) who's the genius in the kitchen."

The resto stuff may come easily to him now, but not the art. Though he wins praise from the likes of Hoffer and Parisian Laundry owner Nick Tedeschi for his gritty abstracts, McMillan feels he is far from hitting his stride at the easel. "Art is super hard for me. It's like Sudoku for me. It doesn't come easy at all and I have yet to master it."

McMillan the artist stands in marked contrast to McMillan the restaurateur. The artist turns inward and reveals a darker, more sobering side, as was amply evidenced in his one-man show of paintings at Galerie Orange in early 2008.

Those who might expect McMillan's work to centre on the cosmopolitan swirl which became all too familiar during his glam

cooking stints could be in for a shock. The seventeen paintings on display focused on solitary images, from almost life-sized canoes to a foreboding military tank to an eerie image of Edith Piaf. Rather than brighten up his canvases with cheery colours, he goes in the opposite direction with faded beiges and ochres and then further mutes them by stripping away layers by sanding and chiselling. Grim for sure, but the effect is utterly powerful and haunting.

This was McMillan's first solo show. He'd done group exhibitions at Galerie Orange and Parisian Laundry over the last few years and his paintings—which fetch up to $8,000—are featured in some of the finer collections in the country.

Not surprisingly, McMillan is his own harshest critic. "I really don't draw well. I struggle through a lot of my paintings. They torment me. Even I find them oddball-like, so I expect that few people will actually get what I'm trying to express. Yet no dish I've ever created has made me feel as good as some of my art."

Nor does he fear being scrutinized by others. "I'm used to being criticized. It happens just about fifty-five times a night at the restaurant," he says, only half-kidding. "There is not a night that goes by without someone calling me an asshole. I don't mind that. I actually applaud it when people speak their minds."

When pressed, he states there is an underlying political theme to his work. "I'm trying to create nicely damaged surfaces that reflect my views. I'm trying hard to do stuff I don't see anywhere. And really I'm mostly trying to please myself. I realize doing art like this is like standing in a room stark naked—and fortunately I do look better naked now since I've lost weight," he deadpans. "It's great if others like it. But if not, I won't lose sleep.

"Honestly, though, a painting is a painting. You can't look too far into it. It's like wine. People get all orgasmic talking about bouquets and about the musk and the truffle scents. Sad but true, it's probably harder to make Coca Cola than wine."

What you'll never see are McMillan's paintings adorning the walls of Joe Beef or his other eateries—and not just because he would have to expand the restos to accommodate some works that are 96 inches wide and 72 inches high. "I find that really tacky and self-indulgent. I prefer

to showcase the work of others." Particularly that of his buddy Hoffer, one of the city's most acclaimed and successful artists.

McMillan's obsession with canoes on canvas is not accidental. "Some may say it's a symbol for me having lost my virginity on a canoe or something. Not quite. I was an avid canoeist as a kid and still love it. It's my escape. My dream is to canoe from Montreal along the St. Lawrence to Kamouraska. I'll do it, too."

Enough about art. McMillan now wishes to reveal how he really feels about some customers. Though his restaurant work would seem to require him to be the ultimate people-person, he can, as noted, be quite surly on occasion. And proud of it. "I will never accommodate those who ask me to decant a bottle of mineral water—and there have been many. No, I'm going to tell them they're out of their fucking minds. And I'm never going to be nice to people who berate my staff, no matter how much they spend. Those are usually the same assholes who stick their gum under our tables." Pause for air. "Do you have any idea how much gum I have cleaned out from under our tables over the years? There are thousands of offenders out there, and I know who you are."

McMillan is getting steamed. Bil, between shucks, is getting amused. "Dave, we really need a couch for you here behind the bar," he says, only half-joking.

"Men of character are few and far between," McMillan retorts. "Would you really prefer it if I were a docile metrosexual?"

A show of hands around the bar suggests perhaps. But upon reflection, the boys at the bar concede they prefer McMillan the maniac to McMillan the docile metrosexual—even if the former unpredictable state can occasionally lead to personal peril for some.

"Ah, I love it," McMillan grunts. "I love this city. It's so fucking cold in the winter that it keeps the riff-raff out—and by that I mean the fuckers who stick their gum under the table. It's cold, cold, cold here. And then suddenly, magically, it's warm and it's spring in Montreal and it's the dawn of the miniskirt. And life is beautiful."

Except for the cretins who stick their gum under the table.

"Dave, you need to start your own religion," Bil tells him. "I think we could even sign up enough people to drink the Kool-Aid with you."

Conceivably. Not so coincidentally, the Rolling Stones' Paint it Black is blaring in the background. McMillan is appropriately revved. "The shit will hit the fan. If we're not ready, we're fucked. Sadly, only those with corn-fuelled monster trucks and guns will survive."

The tirade stops when McMillan's friend and lookalike, Dave Fortin, saunters over to the bar. Fortin works as an electrician, but McMillan plans to hire him as his stunt double. "He can walk around the restaurant and take crap from customers, and I'll take the night off."

McMillan tells Fortin what he will be eating this evening, because he never asks friends or bar regulars what they want—he always tells them. And Fortin's meal this evening—not to be found on any menu—will be: a foie gras/pulled-pork club sandwich.

"Are you trying to kill me?" Fortin asks.

"Of course not," a grinning McMillan protests. "You're my body double. I need you alive."

"Are you for real?" Fortin asks. After getting no response, Fortin announces: "If they invented a character like Dave in a book or a movie, no one would ever believe it."

Ya think?

[Joe Beef, 2491 Notre Dame Street W.]

10:00 p.m.

VELMA CANDYASS LIVES BY THE WORDS of Emma Goldman: "If I can't dance, I don't want to be part of your revolution." Velma Candyass is the lead hoofer and choreographer of the Dead Doll Dancers. She is an anarchist, a ballerina, a burlesque artist, a peeler, a spoken-word performer, a feminist and a teacher—of a course called Lap Dancers for Lovers, if you must know.

Every day is Halloween for Velma Candyass. A little background is in order here: Once upon a time, Natalie Grall's schoolmates would dress up as pumpkins or Princess Leia or plastic Wal-Mart witches. Natalie would have none of that. She went out as a zombie, replete with messy mascara, dripping faux plasma and a lamb shank hanging from her mouth. She was not like the other children in her kindergarten class.

No surprise, then, that little Natalie would one day morph into the mesmerizing Velma Candyass, Montreal's primo zombshell.

"The Dead Doll Dancers have made a pledge: "We'll rot till we drop," says Velma, making strange gurgling sounds. "Sorry, I just crawled out of my crypt and I've got something stuck in my throat."

Blood? Locusts? She won't say. "It may disgust people."

The setting is Velma's fave place for vamping in town: Café Cleopatra on the lower, non-gentrified Main. Downstairs is your basic blue-collar strip-and-grunt club. Performers come in all ages and sizes—with or without dentures. And non-habitués may be surprised to learn that the older and larger peelers—with dentures—are more of a hit with habitués than the young and lithe with all their original teeth.

Upstairs at the Cleopatra is a different story. Stripping transvestites of all ages and sizes and teeth rule on many nights, but they also share space with the likes of Velma and her Dead Doll Dancers. It's an easy alliance.

It's 10:13 p.m. Velma et al are rehearsing their next zomb-a-thon, The Rotting Flesh Revue. No sacrificing of baby goats or turning over of tombstones ... not yet anyway. Velma and the gals are vamping it up in attire—latex, mesh stockings, G-strings and, natch, whips—that would make the babes of Victoria's Secret blush. "Just our usual Berlin-style, Weimar Republic, bad-lingerie look," she elaborates. "I'm proud to say we've wrested Halloween away from the kids and poseurs and have kept it going year-round. We will rot ya!"

Hey, sounds like something we can dance to. This from the same troupe that has had its way with another noted holiday, in the sometimes annual Dead Dolls Commercial Chritma Cabaret, a show decidedly not for those looking for a little seasonal sanctity. Don't know what Santa would say about a spectacle with dancing girls (pretty much clothing-less save for their antlers), naked reindeer, cream pies, candy canes, a real Bad Santa and the Agnostic International Family Choir. As an added enticement, audience members are encouraged to toss snowballs at the performers.

"Guess you could say that the show is more naughty than nice," Velma reasons. "It flies in the face of most holiday traditions, but it does so in a real fun way, taking shots at the conventions of the holiday season. We're just so tired of how crass the season can be and how everyone is expected to be so happy. It's just our way to make a statement about the creeping commercialism of Christmas, and an opportunity to give our fans—such as they are—an opportunity to go to a club where the drinks are among the cheapest in town. Really, does that make me a heretic or a grinch?"

Well, perhaps in the eyes of some, particularly with the inclusion of a puppet show featuring the Bad Santa and a few of his reindeer in compromising positions. And what did Santa ever do to Velma, anyway? "Nothing at all," she retorts. "And I never did him, either!"

She notes that she normally has little trouble getting her troupers to rise to the occasions, but does concede that one singer resented being asked to dress up like a "granny whore" for a Chritma Cabaret. "It's art, damn it," she stammers. "I told her to look on the bright side: There is no preaching or gift-giving whatsoever." Pause. "Burlesque, you see, is much more than stripping. It's also sketch comedy."

On the other hand, Velma's Lap Dancing for Lovers classes are comic only by accident. This workshop, for women only, is a joint initiative of Velma and one of this city's leading sex-trepeneurs, the disarmingly innocent-looking Sebastian Yeung. Some may know Yeung from Joy Toyz, the company that moves the latest in sexual aids and has presented its Schtupperware parties around town the last four years. Or you may know Yeung from her Sexercise programs, designed to develop those abs, deltoids and, of course, pelvises. Yeung operates out of an airy loft on St. Laurent Boulevard, where pink is the predominant colour. Yeung and her engaging sales staff, comprising—big surprise— many Dead Doll Dancers, take a ... hmm ... hands-on approach. But no hard sell here.

Customers are offered a choice of coffee, herbal tea or a peek at the Pocket Rocket iVibe—which is not to be confused with the legendary Habs hockey star. Decisions, decisions: homemade shortbread cookies or the Fukuoku 9000, the world's smallest, water-resistant massager. The only thing missing here is the Beach Boys singing Good Vibrations in the background. But good vibes, manufactured or metaphysical, are the message Yeung endeavours to impart.

Yeung hooked up with Velma after learning that, in addition to her comedy and performance art and anarchist skills, she is a magna cum laude grad of this city's erotic-dance and neo-burlesque circuit. A former professional classical dancer in real tutus—if you can believe it— the rock-solid Velma is serious in class, stressing the body as well as the the bawdy.

And what was intended to be a one-shot deal has now become a weekly affair with more than three hundred women signed up for this Bump-and-Grind 101. The students range in age from eighteen to sixty and in occupation from secretaries to architects to doctors. What they have in common, though, is a sense of adventure. To avoid any undue tension, neither nudity nor men are permitted in class.

"Really, it's all about women simply empowering themselves," adds the copper-haired Velma. "It's about women gaining sexual confidence."

The focus at parties and classes might be on fun, but there is also plenty of emphasis on physiology. "Especially," Velma says, "in our G-Spot Awareness Class." A spot which is not between the F and the H

The Dead Doll Dancers whip the Cleopatra crowd into a frenzy.

spots. In fact, such a snide remark could prompt Candyass to yank out a whip from the Joy Toyz display window and to lash—playfully, natch—the cretin who would dare utter such a crack.

But no time for idle chatter. Velma has to whip—literally—her Dead Doll Dancers into shape upstairs at the Cleopatra. Miss Rococo and Hussy Loveless are in the midst of some serious stretching exercises. "No misbehavin' here," Miss Rococo coos. "Our goal is to bring erotica to another level."

Miss Rococo has not been fully initiated into the Dead Doll dance team. "She must first undergo a hazing," explains Dead Doll Roxie Hardon. "I think of myself as innocent and demure," says Miss Rococo, flashing a mischievous smile. "Well, perhaps it's a cultivated innocence and demureness."

"Trust me," interjects Dead Doll Cammy Mudflaps—Flappy to her friends. "She has no demure side we've yet to discover."

"She sells sex toys by day. How demure can she be?" asks Dead Doll Fortune Cookie—or, depending on her mood, Cookie Fortune.

The Dead Dolls have been together for more than five years. "We get along great, but it would be a lie to say we don't have our share of cat-fights," Velma says. "Actually, the cat-fights are a lot of fun. We try to incorporate that into our shows on occasion. Our fans love it."

And who are these fans? "Straight, queer, from the gutter, from the upper echelons, ex-boyfriends, future boyfriends, lovers, drag queens, drag kings, the deranged and, of course, our parents. Well, some of our parents. Well, maybe just Hussy Loveless's parents," Velma points out.

"Sometimes, jealous showgirls show up and throw eggs at us," says Cammy Mudflaps, a theatre administrator by day and the occasional night. "But we can handle it. We even like it."

Regardless, Velma fears that an egg could take out the eye of one of the Dead Dolls, so she hands out plastic bats and rats at the door for patrons to toss at the girls instead.

"It's a very liberating experience performing, then having stuff thrown at us," claims Cookie Fortune, a thespian by day and the occasional night.

"It's especially liberating when we get down to our pasties," adds Roxie Hardon, an office assistant at an import company "with an adult toy component."

Velma now regales the girls with her recent adventures in Las Vegas, where she was invited to participate in the Miss Exotic World Competition. She performed in one of the galas, but mostly she was there on a reconnaissance mission to lap up the latest in burlesque. "There are two camps: the up-and-comers and the oldsters," she says. "The oldsters don't really approve of the performance-art component of the up-and-comers. But the point is that we up-and-comers are only good when we're bad."

"There's no real standard in the field," suggests Miss Rococo, who hails from the tiny rural hamlet of Porter's Lake, Nova Scotia. "I came to Montreal to be a dancer. Then I met Velma and fell in with a bad crowd. And to think I used to be innocent—or perhaps it has always really been a cultivated innocence. I was brought up to show respect for my neighbours. I even had manners once. Now I'm just a naughty little girl. I'm basically vampy and campy. Because the Ziegfeld Follies, this ain't."

That's for darned sure.

Cookie Fortune is now shoving something that looks like intestines down her panties. Apparently, it's for a homage to Michael Jackson. Miss Rococo is limbering up to rehearse her Bride of Frankenstein number. Which may or may not explain why Flappy is sporting a shirt with the word FUCK emblazoned on the back.

Deejay André Guilbeault, while putting Michael Jackson's Thriller on the turntable, sighs: "If these walls could talk, what stories they could tell. We'd all go to jail and, probably, hell."

That suits Flappy just fine. "More fun there, I bet. Plus, I'd be among friends."

Velma and Miss Rococo are about to perform their Siamese Twins routine. They slip, together, into a gi-normous pair of undies, then an even more gi-normous skirt. "It's just girls wanting to have a lot of fun," says Miss Rococo. "Yeah," shoots back Velma. "Just as long as you don't pass any gas this time. What did you eat today?—"No, don't tell me."

The girls look like little Shirley Temples as they strut innocently together to the music of Rosemary and Betty Clooney: "Lord help the mister who comes between me and my sister ...and lord help the sister

who comes between me and my man."

"Just when people expect us to do something really obscene, we like to break boundaries and do something just so old-school and innocent," Roxie Hardon explains while practising her whipping techniques.

Dead Doll Penelope Percocet arrives late on the scene, but in time to slip into her latex nurse's outfit and perform her show-stopper, Fever.

"That's great," Velma tells her. "But gimme more of those Fosse hands. We love the Fosse hands."

Fosse is the legendary Broadway dude Bob. As for his hands, who knows?

Rehearsal is over. Velma and her crew want to check out the strippers downstairs at the Cleopatra. Mostly for their outfits, not for their moves.

A young Slavic-looking stripper gets on stage and starts prancing. "Oh, yeah," Velma purrs. "I likes her shoes. It's all about the shoes."

"Don't wish to dispute you, Velma, but I think it's 50 per cent shoes," Miss Rococo says.

"You'll notice a high degree of artificiality," Velma says.

"Yeah, these girls don't look like they're really having fun," adds Cookie Fortune.

Velma believes there are two kinds of strippers working the clubs these days. "You've got your ex-Cirque du Soleil gymnast doing dazzling stuff while flying around naked on poles. And you've got your basic untrained performer who just stumbles around and provides gyne-cological views for the guys in gyne-o row in the front. But there is definitely a market for that."

Miss Rococo recounts the tale—apparently not urban myth—of the strip-club patron who died of a heart attack in a booth after a "robust" lap dance was performed for him by his favourite stripper. "He was her regular customer but he was getting on in age. She did her regular dance. Then he suddenly lurched forward and slumped face-first into her boobs. He died in his favourite set of tits. Really, what a way to go," Miss Rococo rhapsodizes. "This is as true a story as I know it to be."

Enough romance. Another extremely fit, Russian-looking stripper leaps on stage. "Wow, will you check out her thigh-high boots, with the seven-inch heels?" Velma veritably squeals. "Her moves ain't too shabby,

either. But chewing gum, on the other hand, ain't too swift."

Velma then explains the hierarchy in the world of stripping—based on her own experiences in the field. "Put it this way: If you're doing lunch at the Cleo, you've got a long, long way to go. There are some rough elements in this environment. You have to keep your head on straight. Either you're doing this temporarily while going to school, or you're stuck doing this until you're fifty with dentures. At least burlesque allows you to grow old gracefully on stage. There's a genuine joy and sense of expression in burlesque."

And whither Velma Candyass at sixty? "If I can still slip into my favourite leopard-spotted outfit and if I can still shake my booty, I'll be there. Perhaps with my own teeth, too. It's all about fantasy and image."

Whether strippers or burlesque performers rule, Velma believes Montreal will always hold on to its title of Sin City. "Erotic dance has always ruled here," she says. "From the old, old days in the 1930s when the Lili St. Cyrs of the world would do their Salome and Dance of the Seven Veils numbers, to today's stumblers who give the guys on gyne-o row their thrills. Moral crusaders will always try to ban it, but they'll never, ever get rid of it."

No sooner does Velma finish her dissertation than Cleopatra owner Johnny Zoumbulakis saunters into the club and greets her with a double-cheeked kiss. On the face, silly. Zoumbulakis is not your stereotypical strip-club owner. In his conservative suit, he looks more like an accountant who spends evenings working as a boy-scout leader. Which is to say he projects a real innocence, which doesn't appear to be cultivated. Born in Greece, he moved to Montreal in the late sixties and began working as a bartender at Cleopatra when it opened in 1975. He became the owner ten years later.

Zoumbulakis is also a man on a mission. Minds out of the gutter, not that kind of mission. "I want the Main to stay the Main," he says, over a coffee. "They've messed around with the upper Main, but I don't want the lower Main to lose its character. Like it or not, this is part of Montreal's heritage. Don't try to modernize the Main. Respect history. Respect the people here. Restore, but don't demolish.

"They've turned the upper Main into a place only the rich can afford and survive. But the lower Main must be maintained as a place

where people on budgets can still go and have a good time and not blow their life savings. I could turn the Cleo into a fancy place if I wished. But why? I keep it clean. I keep it affordable. And I keep all kinds of dancers, not just the young supermodels."

Zoumbulakis has no moral qualms about his trade. "I'm providing a service and I'm providing it at much less than other clubs in town. I have no illusions, though, about what I'm doing. And neither do my customers. They're not coming to Notre Dame Cathedral. They're coming to Cleopatra for a good time, not for a sermon."

And to still have a few bucks left over for a couple of all-dressed steamies and frites a few doors down at the Montreal Pool Room— where few play pool anymore and, in all likelihood, where few will be stuffing their faces in the years to come. For, like the Cleopatra and the other ramshackle operations on the lower Main and in spite of the anti-gentrification resistance efforts of Zoumbulakis, the clock is, fast ticking on this frites palace, too. Pity.

[Cleopatra, 1230 St. Laurent Boulevard.]

11:00 p.m.

THIS ODYSSEY ENDS where it all began for many Montrealers: back at what was once Ruby Foo's on Décarie Boulevard. Ruby Foo's was where it was at for Montrealers back in the 1940s and through the 1970s, before closing in the early 1980s.

It's 11:27 p.m., and we're actually a won-ton's toss away from the site of the now-defunct, now demolished iconic restaurant. We're not in the Black Sheep Lounge of the Ruby Foo's of yore. We're in the Ruby Foo's lounge at Mahjongg, which in turn is housed in the Hotel Ruby Foo's complex. We're sucking back lichee martinis. Mark Saykaly is pumped yet apprehensive. For a quarter of a century, Saykaly has been on a quest akin to the hunt for the Holy Grail. Pardon the religious analogy, but to Saykaly, and countless other disciples in Montreal, Ruby Foo's egg roll and its dry garlic spare ribs were a spiritual experience of the most euphoric variety.

Now Saykaly has heard rumblings that the Ruby Foo's egg roll and dry garlic spare ribs may actually have been replicated at Mahjongg. We'll forgive Saykaly for being somewhat skeptical. He's been down this road before. He was told that various city restos—Yangtze and Le Chrysanthème, among others—had mastered the art of the Ruby Foo's egg roll and/or spare ribs. He tasted. He occasionally enjoyed. But, ultimately, he was left hankering for the originals.

Saykaly, garmentologist/bon-vivant, is alleged to possess one of the city's pickiest palates—deli/Lebanese/Chinese food division. With apologies to Dickens, he states it was the best and worst of times for him twenty-five years ago. That's the time when his beloved daughter Christine was born, and the time when Ruby Foo's died.

For the young and/or unaware, let it be said that Ruby Foo's in its day was the place to be seen, a mecca for the city's business, social, sports, political and wise-guy elites—as well as a magnet for tourists who wanted to hobnob with all of the above. More than that, though,

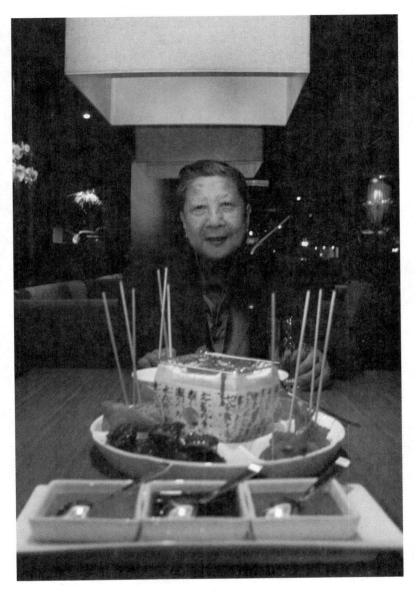

Ruby Foo's original George Wong.

Ruby Foo's happened to serve, in the minds of many, the best damned Cantonese cuisine this side of Canton. Sure, it boasted elaborate Cantonese main courses, roast beef served from that sparkling silver trolley, and even the drop-dead gorgeous cigarette girl sporting the sleekest Oriental-style dress years before such attire was considered appropriate in public places. But for many, the supreme attractions were the egg rolls and the dry garlic spareribs, decreed to be simply orgasmic.

Renée Hunnicutt, one of this town's grande dames, remembered it well. "The egg rolls were just divine. So were the chicken wings, and don't forget the flaming pu pu platter," reminisced Hunnicutt, now deceased but who had spent many of her formative years ensconced in one of Ruby Foo's cozy, leather-lined booths. "On another level, though, Ruby Foo's was the place to be. Anyone who was anyone in this city was there. Relationships were born, died and re-sparked there."

Ruby Foo's was also a primo city nightspot, where patrons could catch the likes of Charles Aznavour in concert. And it was a quirky spot, too. Hunnicutt recalled that Thursday night was Mistress Night "because the maids had the day off and the wives had to stay home to babysit the kids."

Nor is it only citizens of a certain age and era who rhapsodize about Ruby Foo's. One of its most fervent aficionados had yet to hit high school when the restaurant closed. Although Shawn Rosengarten has only vague recollections of chowing down at Ruby Foo's, he was so moved by this institution that he devoted his architectural history thesis at McGill University to the subject. Titled *Ruby Foo's: An Icon to Twentieth Century Montreal*, the thesis is a homage to roadside architecture as well as an appreciation of the resto's place in the societal scheme of things.

Rosengarten is no flake. A one-time member of the Montreal Citizens' Movement executive committee who ran unsuccessfully in a municipal election in the downtown Peter McGill ward, Rosengarten actively lobbies for the preservation of city heritage sites. Unlike the purists, however, he believes that some modern architecture in Montreal should also be preserved.

"It probably sounds foolish for someone of my age to reminisce

about Ruby Foo's, but it had its place socially and architecturally in the city's history," Rosengarten explains. "That stretch around Décarie boasted some unique spots—Piazza Tomasso and Miss Montreal, in addition to Ruby Foo's. Now all that's left from that era is the Orange Julep. It's such a pity.

"People prefer to stay downtown these days, but in the heyday of Ruby Foo's, it was all about the car. From the '40s to the '70s, people loved to drive. Ruby Foo's, with its wild pagodas and different cultural influences, was the perfect example of roadside architecture," Rosengarten adds. "The egg rolls and ribs—and those I do remember—were pretty incredible, too."

Meanwhile, Saykaly, still nursing his lichee martini, retreats to a table at Mahjongg, formerly the site of La Tulipe Noir. After a three million dollar renovation undertaken by Hazel Mah of Le Piment Rouge and her partner George Wong, Mahjongg and the adjacent Café dLux, specializing in breakfasts and desserts, opened in November 2007.

Mahjongg offers the gamut of standard favourites from the five regions of China, such as steamed mixed seafood in lotus leaf, black garlic beef and dried sautéed string beans with Szechwan spices. But of more concern to many Montrealers, it seems that the rumblings were correct. Mahjongg pays homage to Ruby Foo's, not only with its Ruby Foo's Lounge (serving Mai Tais, Singapore Slings and lichee martinis) but also with an entire page of its menu dedicated to Ruby Foo's classics. Mah engaged the services of former Ruby Foo's chefs and waiters to guide the reworking of these classics. But, without doubt, Mah's main consigliere was her business associate Wong, the venerable former Ruby Foo's waiter who went on to become one of the mainstays of the Wong Wing empire, which distributed fresh and frozen Chinese food to retail outlets throughout the land.

Saykaly reports his heart is pounding as he scopes the page and spots the egg rolls and dry garlic spare ribs, as well as such famed Ruby Foo's staples as the pu pu platter, shrimp in lobster sauce, beef steak kew and lobster Cantonese. I believe Saykaly is now salivating. "I've got a nervous stomach," he says. "The anticipation is just overwhelming."

The moment finally arrives. Out come the egg rolls. Saykaly, showing the finesse of a seasoned wine taster, first examines the shape and

texture, then smells the aroma, and then, demonstrating the skill of a surgeon, neatly dissects the egg roll. "The colour is very good, a tantalizing golden," he indicates. "But the ends of the wrappers aren't pinched, the way the Ruby Foo's egg rolls were. The consistency of the cabbage inside is excellent. This is not just an empty shell of fried fat like most city egg rolls are. On the other hand, they've substituted chicken for the original pork filling, but from a health point, I can live with that."

Time for tasting. Saykaly takes a bite. Ponders. Takes another bite. Ponders again. "Pretty damned close," he pronounces. "Not dead-on, but a pleasant surprise."

Saykaly isn't even put off by the fact that the plum sauce isn't the same. That's because Ruby Foo's original egg-roll sauce was actually pumpkin, not plum, but canned pumpkin ingredients are a no-no at Mahjongg.

Consigliere Wong is taking notes. He pledges to go back to the kitchen and emerge with an egg roll that contains pork and whose wrappers are pinched at the end. "I love a challenge," says Wong. "Quality control is what I did at Wong Wing, and quality control is what I will do here now. My goal is perfection, and I will deliver." Fighting words.

Next, it's on to the dry garlic spare ribs. Saykaly studies again, then declares that the colour and texture of the heavy sauce in which the ribs are anchored are a success. "Everyone assumes we used molasses in the original sauce, and that's why they have all failed to duplicate the original," notes Wong, his eyes twinkling. "It's actually a combination of white sugar, soy sauce and garlic. And sometimes the sauce is so thick that we have to water it down."

Saykaly smiles. Now the moment he has been waiting for, the tasting. He deftly grabs a rib with his fingers, smells it for a few seconds, then takes a few chomps. He lowers his hands to the table. He puts his head down for a moment. And finally his judgment: "I'm in heaven!" Saykaly is animated. "This is a home run! They've done it! Others have come close with the sauce, but their ribs have left me wanting. These are bigger, fall-off-the-bone. This to me is perfection. Honey, I'm home! I am so coming back for more."

Just to make certain that Saykaly hasn't lost his senses, a sub-committee of tasters has been conscripted to offer their opinions, and

we all agree with the gourmet garmentologist about both his assessments. In fact, a few of us have attained a high not normally associated with spare ribs—and it ain't the lichee martinis talking, either.

This is all music to the ears of Hazel Mah. She was partly inspired in the making of Mahjongg by Ruby Foo herself. At a time when there was a dearth of women entrepreneurs in general in North America, let alone women from cultural minorities, Foo broke all sorts of barriers by opening a Chinese restaurant in Boston's Chinatown in 1929—perhaps not the most appropriate time to open anything. But soon socialites, politicos and celebs flocked and it became the happening place in town. Not long afterward, Ruby Foo's restaurants sprang up in New York, Providence, Miami, Washington and Montreal.

"Ruby Foo's was a unique Montreal restaurant," says Mah. "I remember when I moved to Montreal from Hong Kong in the 1970s and I came to Ruby Foo's for the first time. It was such a scene. Women in minks and men in expensive suits and expensive cars. I had never seen anything so glamorous in my life."

Before opening Mahjongg, Mah did plenty of research on the woman for whom Ruby Foo's was named. "Ruby Foo was a pioneer. Forget being a woman, Ruby Foo was apparently the first Chinese entrepreneur in Boston. She was a hit with all, the rich and powerful and the gamblers and gangsters."

Mah can relate to Foo. She's something of a pioneer herself. Her downtown Le Piment Rouge is among the city's highest-end Chinese restos. She is a founding member of the Canadian Chapter of the International Women's Forum and a recipient of the Montreal Board of Trade's Femme à l'Honneur Award. She also holds B.Comm and MBA degrees from Concordia University. She and her family operate Le Piment Rouge and El Diablo Rojo in Montreal, Cold Stone Creamery stores in Dallas, and Texas and Panera Bread stores in Southern California. But there have also been setbacks along Mah's path. Be it due to taxes or landlord difficulties, her restaurants Profusion and Sherlock's in downtown Montreal had to close their doors, and labour difficulties in the late 1980s almost spelled the end of Le Piment Rouge.

But Mah is nothing if not a fighter. She had to deal with turbulence as a kid. Her family had to bolt China for Hong Kong as a child after

Mao Zedong came to power. Her dad fought with the Nationalist forces against Mao and died in battle when she was six. While going to school during the day, she took a job at night as a coat-check girl at a restaurant in Hong Kong.

Mah came to Montreal for Expo 67, where she worked as a hostess at the Chinese pavilion. Not long afterward, she married engineer Chuck Mah and put down roots in the city. Her first foray into restaurants was a downtown teahouse in 1978. Two years later, with a $20,000 bank loan, she started up Le Piment Rouge, where she wasn't afraid of long hours (up to sixteen a day), nor of doing everything from purchasing food and washing dishes to busing tables and handling the bookkeeping.

Mah also credits another woman with inspiring her to open Mahjongg: her mom, Precious Flower Chang. "She was renowned for her culinary expertise and energy. She was also considered to be the most gracious host in China, south of the Yangtze River, in the 1940s. She was a marvellous role model. Any success I have today, I owe very much to her."

Back at the table, Saykaly has moved on to a plate of lobster Cantonese. He does the smell and tasting drill all over again. "Unbelievable: this is even better than the Ruby Foo's original," he marvels. "It's not just little lobster pieces, it's huge, succulent chunks. It doesn't get much better than this."

Saykaly is on such a culinary high now that he is quoting John Keats: "Heard melodies are sweet, but those unheard are sweeter."

Elaborate, please, egg-roll guru. "After twenty-five years, the mystique of Ruby Foo's may even be greater than the reality. Our expectations are so high and our memories tend to get embellished, thus the original Ruby Foo's has taken on a life all its own," Saykaly says. "On the other hand, the Diet Coke is exactly the same as I remember it."

And with the last lobster chunk and the last gulp of lichee martini, the day and the night are done. Time to say good-night, Montreal. And time to say good-morning, Montreal.

[Mahjongg, 7655 Décarie Boulevard]

Véhicule Press
www.vehiculepress.com